Designing Brands

Designing Brands
Market Success through Graphic Distinction

GLOUCESTER MASSACHUSETTS

ROCKPORT PUBLISHERS

Emily Schrubbe-Potts

First published in the United States of America by
Rockport Publishers, Inc.
33 Commercial Street
Gloucester, Massachusetts 01930-5089
Telephone: (978) 282-9590
Facsimile: (978) 283-2742
www.rockpub.com

ISBN 1-56496-668-2

10 9 8 7 6 5 4 3 2 1

Design: IE Design

Printed in China.

[Acknowledgements]

I'd like to thank my husband, Ted, for transforming our spare bedroom into a wonderful workspace, for always listening to me and showing interest in my work, and for his ability to always make me laugh. I must also thank all of the designers who contributed their branding expertise and wonderful projects to make this book possible. And finally, I'm eternally grateful to my parents, Glen and Margy Schrubbe, for their lifetime support and encouragement.

Designing Brands

[Contents]

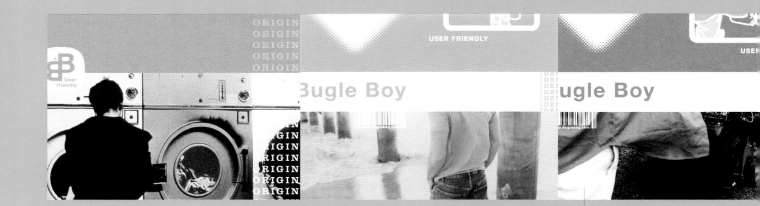

INTRODUCTION

GIL HANSON, PRINCIPAL OF HANSON ASSOCIATES, PHILADELPHIA

Today we live in a branded world. Brands are more than logos and marketing jargon. They are icons of our society, reflecting our personal preferences, values, and lifestyles. Many of us view our self identity through the brands we support and buy. Whether it's a car, computer, wine, or even where we do our banking, we create brand relationships with what feels good, what supports us emotionally, and what helps define us to others. We feel a certain trust and affinity to "our" brands. That personal relationship is the difference between buying a BMW or Volvo, a Dell or Macintosh, or between Louis Jadot and Mondavi.

In this communications media age, brands act like discriminating beacons, enabling us to pre-qualify our purchase decisions. As consumers, we have to make so many choices in so little time we allow the brands to guide us to the right choice. With distinct personalities built by culture, advertising, colors, shapes, and sound, brands become larger than any one product or service, representing multiple lifestyle value systems. We learn to trust and respect our brands as a validation and confirmation of what is a better choice.

To truly understand and exploit a brand's potential, marketers and designers alike need to understand how and why it interacts with its target audience. They need to have a clear vision of the brand's core values and be willing to stay in touch with the customer's relationship with the brand. Just as critical, is the need to be able to look into the future to determine how to keep the brand fresh in order to meet new generations of customers.

Volkswagen demonstrated this in the late '90s through a synchronized brand attack designed to capture a new, young customer base. They accomplished this goal with the successful launches of the new Beetle and Passat models. Both cars are carefully associated with a particular buyer. The brand, the product, and the customer are linked emotionally in one complete brand experience.

As we look towards the new century, the customer will be motivated to make a purchase if the product or service provides value and rationale. What will weaken the sale most often is losing touch with the customer, disassociation with the brand's core value to the customer, and fragmented brand communications. Packaging, advertising, print materials, electronic communications, and all other message carriers must be linked and synchronized to the product and service as one brand experience.

[**1**]

EDWARD M. O'HARA, SENIOR PARTNER & CHIEF CREATIVE OFFICER OF
SME POWER BRANDING, NEW YORK CITY

Developing a visual identity for a new brand is just the tip of the iceberg—everything that precedes it relies on intense brand analysis and evaluation of that brand's positive attributes and whom the brand will be targeting. This is how design and branding professionals integrate business know-how with consumer research in order to create and design successful brand images.

Working with start-up brands is the most fun because the process at its inception is all "clean-slate thinking." We lay the foundation for brands and their future growth as well as create the basis for all of that brand's business activities to follow. It is a very satisfying experience for all involved.

In the beginning, the branding team has to start with the development of a brand architecture. This will govern the brand not only from a design and identity development standpoint, but it will also determine the look and feel of all marketing communications and advertising efforts. Most importantly, the brand architecture process delivers the brand essence, the brand positioning statement, and an in-depth analysis of the target consumer's demographic and psychographic profiles—key components in the building of a brand.

BRAND ARCHITECTURE begins with the establishment and assessment of the positive attributes of the brand (consumer benefits) and then identifies those attributes as either intrinsic (physical) or extrinsic (emotional) properties of the brand. These brand assets are further analyzed to reveal the **BRAND ESSENCE**—a few words or thoughts that represent the brand to the core and target consumer. Brand essence is the heart and soul of the brand and only when it is established should the process begin.

The next step is **BRAND POSITIONING** statement development, which is defined as the consumer's sense of the tangible and intangible benefits of the brand and why it is better than the competition. Brand positioning serves as a guideline for marketers to sell their brand to **TARGET CUSTOMERS**. The consumer study completes the brand architecture process and allows (after a creative brief is developed) for the brand design team to begin. The creative team now knows the brand's essence, positioning, and to whom they are speaking.

This strategic branding approach to designing start-up brands will give marketers, designers, and consumers the clearest picture of that brand and guarantees brand success. This methodology communicates critical brand imagery to target consumers, thus creating motivating purchase intent and long-term brand equity. It is a fun and enlightening process, and for start-up brands it is essential to their success and longevity.

DESIGNING
A BRAND FOR A
START-UP

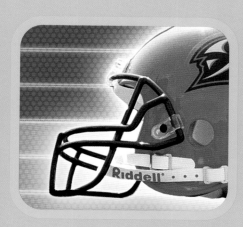
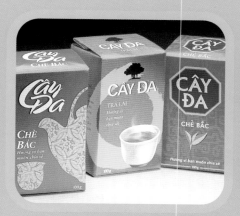
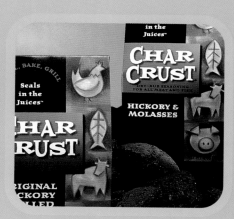

THE
COMPLETE BRAND

AVENGERS AFL TEAM
BRAND BY SME POWER BRANDING

Ed O'Hara, senior partner and chief creative officer at SME Power Branding in New York City, does not think there is any difference between branding for sports teams—which is his firm's niche—or any other service or product. In fact, he got his start in consumer branding, and he says his entrée into sports "happened by dumb luck. One slow day of my life I picked up the Red Book of advertisers and decided to drum up some new clients. I went under *A*, and there was Adidas. The woman there said she was taking a new position in major league baseball as vice president of creative services, and I asked her if I could call her, and she said 'yes,'" O'Hara recalls. "She had no resources and I was showing her toothpaste and soap packaging. She hired us to do a centennial mark for the St. Louis Cardinals and then a license program called Rookie League. Then we started hawking this work to other leagues, to colleges, to other teams, and eight years later we're the dominant brand identifier in sports."

That dumb luck has afforded SME the opportunity to develop brands for NBA teams, including the Utah Jazz, as well as major sporting events such as the 1999 World Series, the Nokia Sugar Bowl, and the 1999 NBA Finals broadcast on the NBC television network. So it was no surprise that Casey Wasserman, owner of a newly formed Los Angeles Arena Football League (AFL) team, commissioned SME to develop a brand for his team.

[THE CHALLENGE]

"Being in Los Angeles, it was very important for me to compete in every way, but most importantly in perception, with the Lakers, Dodgers, Clippers, and Kings—we needed to be a first-class team, and one of the most obvious representations of that is in the brand, from the name and logos down to uniforms and letterhead," Wasserman explains. "I focused on finding a firm that could fulfill those needs all the way across the board for an extended period of time, and SME was identified to me pretty quickly."

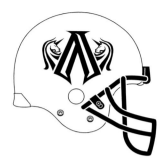
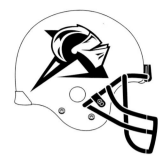
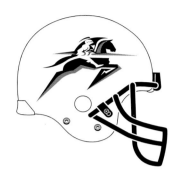

[above and right]

Once the name Avengers was chosen for the new Los Angeles AFL team, SME Power Branding designer Chung-deh Tien came up with several concepts. "At first I just thought of a Greek mythological character of a very traditional stylized warrior," he says. Tien also incorporated a horse into the design, and some variations using the letter **A**.

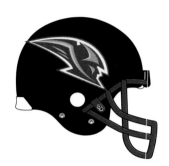
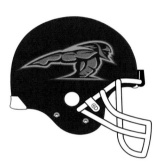

"WE NEEDED TO BE A FIRST-CLASS TEAM, AND ONE OF THE MOST OBVIOUS REPRE-SENTATIONS OF THAT IS IN THE BRAND, FROM THE NAME AND LOGOS DOWN TO UNI-FORMS AND LETTERHEAD."

"YOU WANT TO HAVE TAGLINES THAT MOTIVATE A PURCHASE. IT HOPEFULLY GETS PEOPLE OFF OF THEIR COUCHES AND SPENDING MONEY ON YOUR TEAM."

The first thing Wasserman and SME creatives did was come up with a name for the AFL team. "I had intentions of getting a name that was LA-based, but I couldn't find any that I liked, so then I focused on a name that was unique and inspires a lot of emotions," Wasserman says. "I didn't want to be another cat or dog—that was tired and old and boring to me."

O'Hara recalls, "We had to create the attributes that the brand would have and we had to suggest name candidates that would meet those brand attributes or assets." So, he asked Wasserman to identify his vision for the team, and how he wanted consumers to perceive it. Specific characteristics he suggested were contemporary, aggressive, professional, and elegant. "This helps us focus our energies to come up with a more qualified solution," O'Hara says. "So we had names like Knights, Avengers, and Bombers. Avengers was chosen, which I was happy with, because I think that name can mean a lot of things to a lot of people. And the design objectives of the brand became extensions of those attributes—contemporary, fresh, elegant.

Once the name was determined, SME designers went to the drawing board and came up with several design approaches. Chung-deh Tien, SME senior designer says, "I call it the shotgun approach, where you come up with as many ideas as you possibly can."

As Wasserman recalls, "They came back with sixteen designs. It was pretty clear from the start what route we were going to go down, but we continued to explore three or four other routes as well." The design that was ultimately chosen "represented what I thought Avengers should be—it was more than just an *A*, it was more than just a horse, it was more than all those things. It really captured the mythical and warrior type qualities I thought Avengers had," he says.

SME also came up with a tagline for the team. O'Hara explains, "Here's a new ownership group that has to sell tickets and attract sponsors, so we look at the same attributes and positioning statement, and we came up with *Claim Your Turf!* An avenger is someone who can claim and physically take control, and turf has a relevance to football. It's also a call to action. You want to have taglines that motivate a purchase. It hopefully gets people off of their couches and spending money on your team."

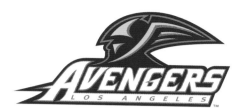

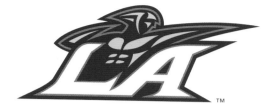

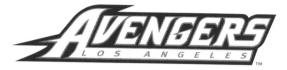

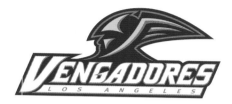

[above and right]

Since all the sports teams incorporate several logos and identities under one brand, SME developed different marks that would appear on a variety of materials, including helmets, uniforms, brochures, direct-mail pieces, and even a Spanish brand mark since Los Angeles is such a multi-cultural destination.

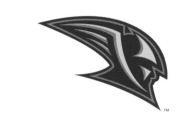

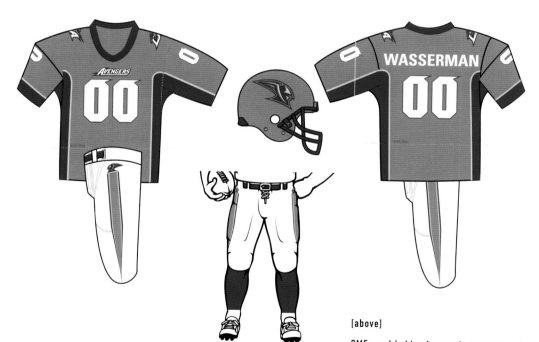

[above]

SME used bold colors and strong graphics on the Avengers uniforms. Casey Wasserman, the team owner, wanted red as the Avengers' proprietary color since most of the AFL teams were using dark colors such as dark blue and black. The home uniforms (seen here) are primarily red, as opposed to the away uniforms, which are mostly white and blue.

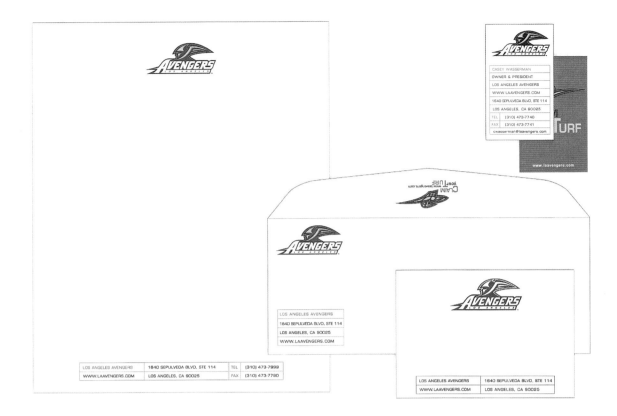

[IDENTIFYING AND UNDERSTANDING THE CONSUMER]

With the design and tagline finalized, Wasserman and O'Hara needed to determine a target audience since the AFL is a different market than the NFL. "AFL price points are lower than the NFL, and initial AFL research indicated that the audience is comprised of younger guys, and it's date night for a lot of these folks. It also attracts a large minority scale—African Americans and Latin Americans," O'Hara says. Although little market research was conducted before the team's solid characteristics were defined, some of the initial designs were presented to season ticket holders of the Los Angeles Kings and Lakers because a cross-promotional desire was prevalent, and it was important to get this group's opinion since the Avengers would be sharing the Staple Center with the Kings and Lakers.

"I'm a big believer that market research is relatively ineffective with things that haven't happened yet. If people don't have something concrete to point their finger to, it doesn't matter," explains Wasserman. "Market research in retrospect is much more effective."

O'Hara agrees, to an extent. "You have to make a business decision to get in front of the consumer for a disaster check. Don't make it a democratic process," he says. "According to our process you need a verification from the consumer base. Many people use consumer research to create the verification—we just want to know if consumers like it. When you start making decisions based on every comment that every person in a focus group makes—which, by the way, are affected, because [the people in the groups] influence each other with their comments—that's when we put too much credence into it. It gets too nitpicky, too passive. I like to see business owners make business decisions, not get a straw vote every time they have to make a decision."

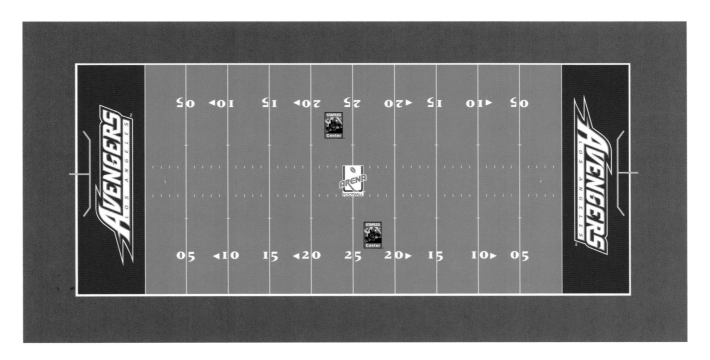

[above]
SME incorporated team sponsors'
names into the home field graphics.
The Adidas and McDonald's logos are
strategically placed in various
positions on the field for high
visibility no matter where patrons are
seated within Staple Center.

MANY PEOPLE USE CONSUMER RESEARCH TO CRE-
ATE THE VERIFICATION—WE JUST WANT TO KNOW
IF CONSUMERS LIKE IT. WHEN YOU START MAKING
DECISIONS BASED ON EVERY COMMENT THAT
EVERY PERSON IN A FOCUS GROUP MAKES... IT
GETS TOO NITPICKY, TOO PASSIVE. I LIKE TO SEE
BUSINESS OWNERS MAKE BUSINESS DECISIONS,"

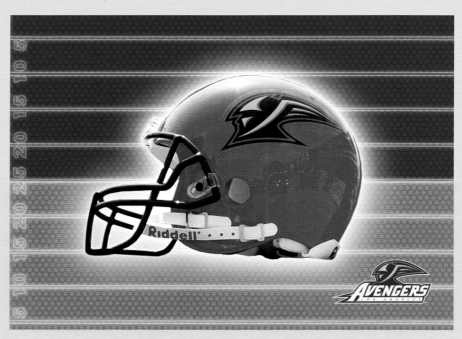

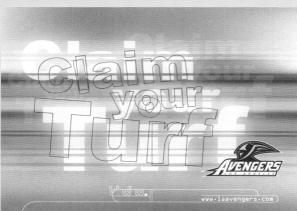

[left]

These are just two of the four
postcards that were designed for
direct-mail campaigns to generate
public awareness of the new AFL
team.

A unique challenge inherent in branding for sports teams is that there are several messages that
need to be communicated to consumers in different formats, so many logos need to be developed.
The primary mark is on the helmet, according to O'Hara. "It has to be simple and it has to com-
municate what the team is. The second logo is a word communication—LA Avengers. We also did
a Los Angeles story—just a Los Angeles ligature logo with and without the Avenger," he explains.

In addition to all the regular identifiers, SME developed a Spanish brand for the Avengers, which
translated to Vengadores, at Wasserman's request. O'Hara says, "That was very smart of Casey
to do that so he's not alienating himself from the Latin community. He's also having the games
broadcast on Spanish-speaking radio stations."

"We've treated this the same way you would treat an NFL team. We haven't treated it as minor
league or small time," Wasserman explains. "We're taking all the steps that any expansion team
would have to take in creating an identity. I think we're one of the first teams in the AFL to do that."

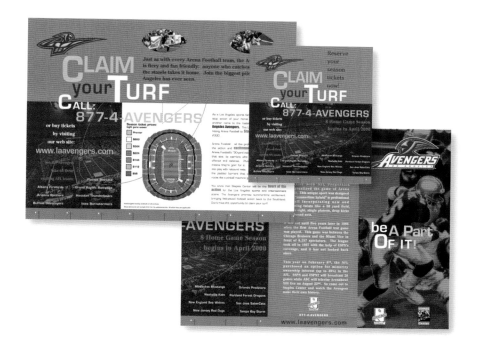

[above and below]

The Avengers seating brochures, in both English and Spanish, feature a diagram of the Staple Center. The seating chart is color-coded by sections so patrons can easily navigate their way to their seats.

"IF YOU'VE CONNECTED WITH YOUR CORE CONSUMER, AND YOU HIT TARGET CONSUMERS WITH YOUR BRAND IDENTITY AND COMMUNICATIONS, YOU'RE GOING TO INCREASE REVENUE STREAMS ON ALL YOUR LINES OF BUSINESS."

SME POWER BRANDING
THE WHOLE BRAND FROM A TO Z

SME Power Branding attacks its sports projects purely from a branding perspective. "We try to tell brand stories that are robust and highly textured. They don't leave anything missing. In this day and age with four or five logos for every team, you don't want redundancy," says Ed O'Hara, senior partner and chief creative officer.

"We'll do the surface graphics for the playing field, complete with sponsors' logos. Anything that visually brands a team—colors, typography, illustrations, the positioning [statement—hopefully communicates a continuity," he adds. In addition to designing] the team logos and creating a brand identity, SME puts together a style guide and a graphics standards manual for usage of the logo.

But O'Hara admits, sports branding was not always a priority for teams. "It happened to become fashionable in the early '90s and trendy to wear clothes that represented your favorite team, so merchandising was a huge thing. In the early days we were thought of as a licensing function—if you redesign your logo, you'll sell more T-shirts. But I've always fought that notion," O'Hara explains, "because I felt if you branded right, if you've connected with your core consumer, and you hit target consumers with your brand identity and communications, you're going to increase revenue streams on all your lines of business—ticket sales, sponsorship, fundraising, viewership, merchandising, and so on."

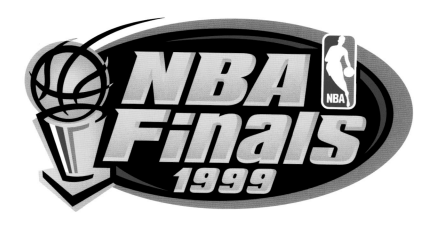

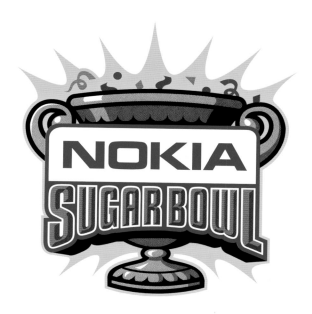

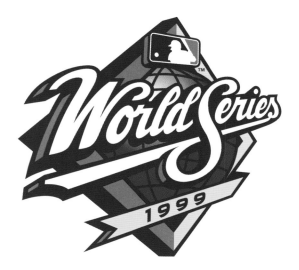

[left and following page]
In addition to the firm's work for individual sports teams, SME created these brands for professional, national sports events. For instance, the 1999 NBA Finals, 1999 World Series, and 1999 Nokia Sugar Bowl icons were all created using an illustrative approach and bold colors emphasizing the excitement and energy of these high-profile events.

"THE AUDIENCE IS THERE AND YOU JUST HAVE TO TALK TO THEM IN A LANGUAGE THEY UNDERSTAND, THAT EXCITES THEM, AND THAT MOTIVATES A PURCHASE. THAT'S WHAT YOU'VE GOT TO DO IN AS MANY WAYS AS POSSIBLE."

There was also a growth trend in sports—sports became more popular and all the leagues were adding more teams. "It used to be win big, and we'll sell more shirts and tickets. Not everybody can win," he notes. "The San Jose Sharks are an unbelievable story. They didn't have a winning season for seven years, but they were one of the top-selling teams and had high attendance at every home game. They did a great job with their brand."

With all the competition in every sports league, motivating consumers to buy into a particular brand takes more than just luck—it takes branding expertise. As O'Hara says, "It may be that the audience is there and you just have to talk to them in a language they understand, that excites them, and that motivates a purchase. That's what you've got to do in as many ways as possible."

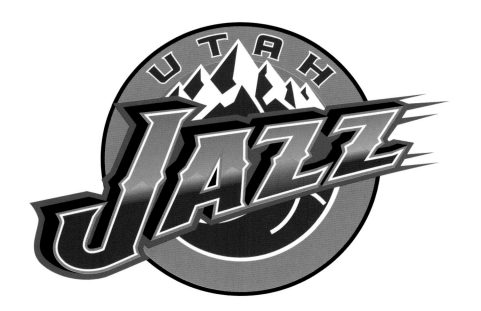

[left]

Incorporating bright blues and purples for the Utah Jazz brand identity, SME created the strong mountain graphics behind the Jazz word mark. The stylized, jagged lettering has a shadow giving the illusion of a fast-moving object, such as a basketball player in motion.

A CULTURAL LESSON

CAY DA TEA
BRAND BY THE BONSEY DESIGN PARTNERSHIP

When The Bonsey Design Partnership, based in Singapore, took on the task of designing a new brand of tea for Unilever, to be distributed in Vietnam, it was an eye-opening cultural experience. Not only was there a language barrier for the designers to conquer when creating the packaging, they also had to identify and relate to the Vietnamese lifestyle and culture through the graphics.

The project kicked off with a trip to the client's office in Ho Chi Minh City (South Vietnam) where the designers were given an extensive description of the objectives. The brief stated that the designers needed, "to create a design for a new Vietnamese tea brand that will appeal to the Vietnamese tea drinker's heart and soul. It is the Vietnamese tea that he can identify with through the roots of his family, birthplace, and nation. 'This is my tea and my culture'."

Initial consumer research had already been conducted by the client to support those objectives, and it provided useful information about the social habits and economic decision impulses of the consumers. The designers learned that since tea is so intimately related to the Vietnamese culture, it is not an impulsive purchase. "In a society where respect for elders and hierarchy is important, so is the choice of tea offered to the guest," says Kris Foo, senior designer at Bonsey. The client offered this example to Foo: When a man serves his father-in-law tea, it must be superior in quality than the tea he would serve himself. So quality, price, and occasion play important roles in the buying decision.

[above]
Designers at The Bonsey Design Partnership explored several visual routes to present to Unilever, which was preparing to distribute a new brand of tea in Vietnam. They experimented with different type treatments, as well as an array of bright colors.

[IDENTIFYING AND UNDERSTANDING THE CONSUMER]

After the initial client meeting, Bonsey's creatives were taken on a field trip through both North and South Vietnam to observe the people and gain a better understanding of the commercial and social environments firsthand. Even though Vietnam is only a two-hour flight away from Singapore, the disparities between the two cultures are evident. Vietnam has not attained all the technological and architectural advances that many Asian countries have come to rely on and enjoy. In fact, the villages are very much traditional and communal in nature, and the people relish their heritage. "They are warm and hospitable to guests and friends. There is great pride and emphasis on core values like friendship, filial piety, and harmony," Foo explains.

The creatives' understanding was crucial since the names being considered for the tea derive from, and have their cultural roots in, the Vietnamese culture: Lang Xua, meaning old village, and Cay Da, meaning Banyan tree. Foo also acknowledges the importance of understanding the past. "One cannot attain an understanding of current Vietnamese behaviors without basic knowledge of the traditional culture," she says.

Most Vietnamese people still live in villages, so the term Lang Xua is significant. A village has physical attributes, like a bamboo thicket that sets the parameters of the community area. Within this compound there are areas that are designated for certain social activities and these areas set the hierarchical status of community members. For example, there is a main hall where the elders gather to discuss community issues. "I watched a group of ten elder women gathering for such an occasion," Foo relates. "Though I couldn't understand the language, nor wanted to impose on such a private affair, their serious expressions and bearing impressed upon me the significance of such a moment. The old village is a name which most, if not all, Vietnamese can relate to and recall special memories."

The Banyan tree is also an important symbol that represents the anchor point of all the social activities within the village, including sharing tea. Although consumers in the study strongly indicated that the Banyan tree bore greater significance, it wasn't immediately established as the name.

"The client was very focused on what they wanted to achieve with this packaging. It had to be simple (consumers had to know it was tea immediately), Vietnamese, and bold. Initially, this did not sound very difficult, but even with all the research materials and information to execute an idea with those criteria, it's a much taller order than we imagined," Foo explains. But, she

"IN A SOCIETY WHERE RESPECT

FOR ELDERS AND HIERARCHY IS

IMPORTANT, SO IS THE CHOICE OF

TEA OFFERED TO THE GUEST."

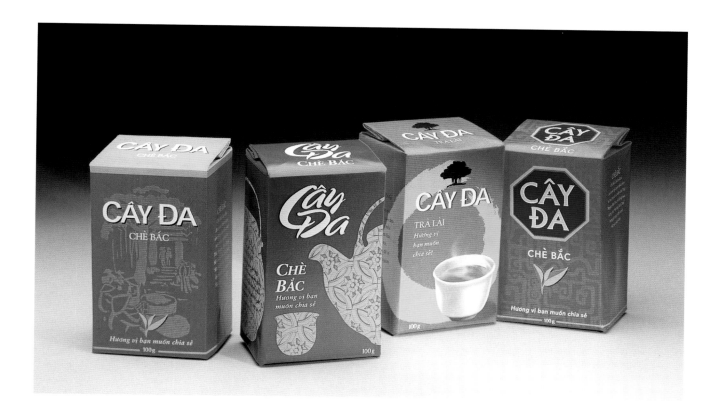

[above]
To give the client a better perspective of how the design would actually look on the package, Bonsey's designers created 3D mock-ups to present to Unilever.

"IT IS BONSEY DESIGN'S PRACTICE TO **COVER ALL POSSIBLE ANGLES** ON A PROJECT, BOTH **FROM A GRAPHIC PERSPECTIVE AS WELL AS A STRATEGIC PERSPECTIVE.** TOGETHER THIS MAKES IT ALMOST **IMPOSSIBLE FOR A CLIENT TO TOTALLY REJECT** OUR IDEAS. DESIGNS MAY BE REFINED, **BUT IF THE FOUNDATION IS STRONG,** THERE ARE MANY WAYS TO APPROACH AN IDEA."

[above]

The client settled on this logo for the new brand of tea named Cay Da, which is Vietnamese for "Banyan tree." The swoosh through the *D* represents the steam that rises from a tea pot's spout.

adds, "It is Bonsey Design's practice to cover all possible angles on a project, both from a graphic perspective as well as a strategic perspective. Together this makes it almost impossible for a client to totally reject our ideas. Designs may be refined, but if the foundation is strong, there are many ways to approach an idea."

The creatives also learned that the packaging for the new tea would be distinctly different from traditional Vietnamese tea packages which are sold by tea vendors where most people shop, as opposed to supermarkets. Tea is most commonly sold in large "cookie jars" where the vendor scoops the loose tea leaves (chosen by the customer) into plastic bags for sale. The client decided it would be better to put the tea in small consumer-sized boxes making it more convenient to use, and guaranteeing the tea a longer shelf life.

[THE DESIGN]

Armed with the information they learned about the Vietnamese culture, the designers created several three-dimensional mock-ups using both names to present to the client. Foo says the mock-ups "aided comprehension and the ability to touch and feel the product. We wanted them to be as realistic as possible."

The client eventually chose the Cay Da name, since it was the most literal approach, so the designers then came up with concepts that focused solely on the Banyan tree. Many of the designs incorporated traditional Vietnamese images such as village women clad in Ao Dai (traditional women's garb) sharing tea by the tree, oriental tea pots, and ancient-looking renderings of the tree itself. The creatives also experimented with different type treatments, finally settling on a simple, clean serif typeface. An aromatic swoosh coming from the teapot flows through the letter *D*.

A Banyan tree symbol was also incorporated into the design on the packaging to set it apart from the competition, and colors were used to distinguish the Green Tea and Jasmine varieties. "The package had to have a visual symbol of tea, and consumers had only to look at the teapot and there wouldn't be a doubt as to what is inside the pack," Foo explains. "The pattern carries the 'Vietnameseness' of the brand. And while it may not be the one we initially proposed, our developmental work created an opportunity to incorporate the symbol of the Banyan tree. We believe this helps enhance the ownership and identity."

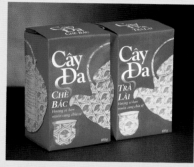

[above]
The final packaging incorporates
a traditional tea pot which is
decorated with a calligraphic
rendering of the Banyan tree. Each
tea flavor is represented with
a different color scheme on the
tea pot.

[above]
To ensure the brand is always proper-
ly represented, The Bonsey Design
Partnership developed a brand
manual.

OVERCOMING
CONSUMER PERCEPTION

MAIN ST. CAFE
BRAND BY MURRIE, LIENHART, RYSNER ASSOCIATES

Gehl's Guernsey Farms, located in Germantown, Wisconsin, had a revolutionary idea in the mid-'90s—take the iced cappuccino beverages they had already been selling in bulk to cafés, and package and promote it to the consumer market. As John Slawny, marketing director for the dairy manufacturer explains, "While we found that the product was successful, only about 60 percent of the coffee shops were selling it as Gehl's. Some of them were actually telling their customers it was being made fresh in the back room. This is how we knew we had a winner product." Unfortunately, a lot of other companies had the same idea and were already bottling their coffee concoctions and making a fortune. In addition, Gehl's had a quality perception issue that posed a unique challenge when trying to compete in this new market—it packaged its product in a can, not a glass bottle.

"As a company, we are on the leading edge of some of the new dairy packaging technologies. It used to be that in the past the way to completely sterilize a milk-based product put a lot of stress on it—you had to raise the temperature very slowly, boil it for about thirty minutes, then lower the temperature very slowly," Slawny says. "We found a way to do it in a matter of seconds, but the quick heating and cooling put a lot of stress on the package rather than the product, and glass bottles and aluminum cans just couldn't accept that kind of stress." Gehl's solution? Metal cans.

"Of course," he adds, "this was a very important decision for us because you have a choice of a better product in a less accepted package, or an inferior product in the package of the day—glass. We felt in the long run our product was only going to survive if people really got the fresh taste from it."

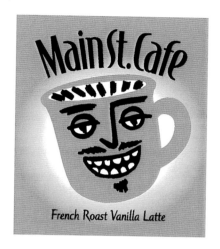

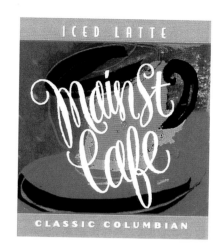

First Round of Concepts

[above]

John Slawny, marketing director at Gehl's Guernsey Farms, brought in Murrie, Lienhart, Rysner Associates to create Main St. Café's new design. Slawny had specific design objectives in mind for the brand. MLR's Mike Kelly recalls, "The consumer was a young, sociable person acquiring a taste for coffee, and John really wanted that to show on the packaging."

After the illustrative style was chosen for the packaging, the designers created the "bull's eye" brand mark, and integrated it with the illustration. "The logo and illustration worked together seamlessly to create the brand image," Kelly explains. "It also quickly communicates, through the color, what flavor the beverage is," since he and Slawny learned in the focus groups that consumers have strong feelings regarding what colors go with what flavors.

[THE CHALLENGE]

However, Slawny realized that consumers' perceptions were strong enough to influence their taste buds. In the early stages of developing the iced cappuccino product, he tested it with consumers by telling them they were tasting the same product packaged in three different ways: one that was prepared fresh in the back room, one that was bottled a month prior, and one that was packaged in a can for a month. "Sure enough, they would tell us how much better the fresh product tasted, and how the glass product tasted almost fresh, and how the canned product had a very tinny flavor. All three samples had actually been freshly prepared. The metallic flavor was all in their heads. At that point, we realized what a challenge we were up against," Slawny recalls.

But Gehl's wasn't in a financial position to address its superior packaging process with supplemental marketing and advertising materials. Slawny also adds, "A process story on the package simply wouldn't get read if consumers passed over our brand, and package designs that really focused on fresh taste were too commonplace to offer a meaningful advantage in our category."

The company knew the only way they could really get an edge in this market initially was to have a strong shelf presence, so the design firm Murrie, Lienhart, Rysner and Associates in Chicago (MLR) was called in to create a distinctive brand identity. Mike Kelly, the creative director on the project says, "They had the technology to make a rich, creamy, shelf-stable product. It really tastes great out of the can, but the consumer perception is that it wouldn't taste as good because of that. Gehl's was concerned about that perception, even though all the research indicated that the product was superior tasting and it was probably the closest thing that you could get in the marketplace at that time without going to a coffeehouse."

Slawny notes, "We knew that the people who were going to buy this product were very interested in the coffee culture of the time, so we wanted to capture all the feeling of the coffee shop in the design on the can—keeping it fresh and young, but not too young."

Another challenge emerged during the introduction period: Starbucks was simultaneously introducing its Frappuccino drink, and according to Kelly, "Starbucks was probably our biggest competitor. The other brands tasted like liquid chalk."

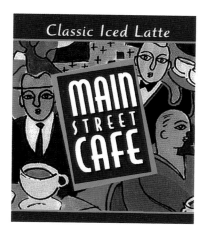

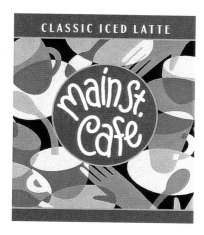

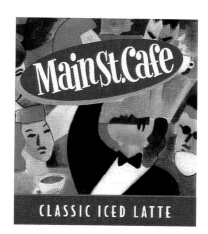

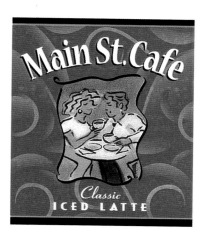

First Round of Concepts

[above]
Mike Kelly, creative director at
MLR, and design director Amy
Leppert developed these first
round concepts to present to
focus groups aimed at translating
the "café experience" for Main
St. Cafe, Gehl's new iced
cappuccino drink product.

"YOU HAVE A CHOICE OF **A BETTER** PRODUCT IN A LESS ACCEPTED PACKAGE, **OR AN INFERIOR PRODUCT** IN THE PACKAGE OF THE DAY—GLASS. WE FELT **IN THE LONG RUN** OUR PRODUCT WAS **ONLY** GOING TO SURVIVE IF **PEOPLE REALLY GOT THE FRESH** TASTE FROM IT."

[DEVELOPING A STRATEGY]

The first thing Slawny and his marketers did was come up with an appropriate name for their new product. "Our objective in the packaging was to try to capture all the fun, sociability, and the warm, accepting atmosphere of the cafés—and the cafés in particular that were already serving our product—so we called it Main St. Cafe," Slawny notes.

With their work cut out for them, Gehl's did market research among a number of different age groups with package mock-ups supplied by an ad agency to get a feel for what consumers liked. Slawny presented the research results to Kelly and design director Amy Leppert, who worked with illustrators to come up with some preliminary design solutions. Slawny and Kelly then took the different variations and presented them to four focus groups.

Surprisingly, the people in all the groups started mixing and matching the designs on the cans. "They had very specific colors for very specific flavors," Slawny says. "Chocolate is supposed to be red, and vanilla is supposed to be blue. They had no rational explanation for this, but they were very insistent that vanilla isn't turquoise, and chocolate isn't brown.

"There were certain visual images and cues that consumers related to better," Kelly adds. "They liked the timeless, classic illustrative style—not the really fun, funky stuff. It didn't pull the right triggers. It needed to be a little more sophisticated." José Ortega rendered the final illustration, and Leppert developed the "bull's eye" Main St. Cafe brand mark in accordance with the colors in the illustration.

"The illustration has so much more personality than any other product that's in a glass bottle, except for Starbucks—but theirs isn't so much the personality of the bottle as the brand name," Kelly remarks.

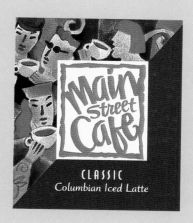

CLASSIC
Columbian Iced Latte

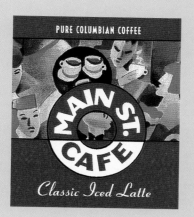

PURE COLUMBIAN COFFEE

Classic Iced Latte

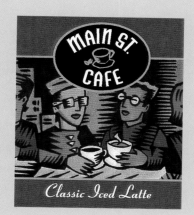

Classic Iced Latte

CLASSIC ICED LATTE

Overwhelmingly, the focus groups chose the final design (upper right) because of its "timeless, sophisticated look," Kelly says.

[

"IT'S ALL ABOUT EXPECTATIONS. THE MARKETS WHERE WE GOT INTO FIRST, WHERE THE CATEGORY REALLY DIDN'T EXIST, CONSUMERS TRIED US. THEN, WHEN THE GLASS PRODUCTS CAME OUT, THEY TRIED THOSE AND REALIZED OURS WAS BETTER."

]

[IMPLEMENTING THE SOLUTION]

The strong graphics on the packaging have definitely helped boost sales of the product since its introduction. According to Kelly, "When Gehl's took that package into limited distribution on the East Coast, the distributors said Main St. Cafe outsold a lot of other products in a 700 store search. They found out that the packaging was the motivating driver for purchase in stores where consumers didn't actually get to taste-test the product. Attitude and attractiveness of the package is what compelled the consumer to pick it up and give it a try. Of course, once they tried the product, they realized the taste advantage for themselves."

Slawny adds, "We did end up with a lot more competition in the market than we anticipated. Rather than having one competitor, we had several. In the markets we got into very early, Main St. Cafe continues to shine." However, in the markets where Main St. Cafe emerged after the competition, the sales figures did not match up compared to the markets they entered first— largely because of the can.

"It's all about expectations. The markets where we got into first, where the category really didn't exist, consumers tried us. Then, when the glass products came out, they tried those and realized ours was better," Slawny says. "But in the markets where we came in second, consumers had such bad experiences drinking poor-tasting products from the glass, they were reluctant to even try the can, so we've had to be more aggressive with our promotions."

Despite that, Main St. Cafe continues to be a successful contender in the market where so many others failed. In fact, Slawny admits that consumers brought another selling point to his attention. "People were e-mailing us and saying, 'There's so much calcium in here. It's very low fat,' and 'I'm not using Main St. Cafe to replace my coffee, I'm using it to replace my Snickers bar in the afternoon.' The use was very different than we actually thought, which led us, two years later, to include a secondary message on the back of the package noting that the product is also a healthy, low-fat snack."

He's also quick to point out that he didn't want the secondary message to interfere with the successful design MLR had come up with. "We were very careful to make sure it was a back panel message and that it didn't distract from the primary message. The can packaging is one of the things we hit correctly from day one, and we've been very careful not to mess with the front of the packaging because the strong graphics have been very successful for us."

"OUR OBJECTIVE IN THE PACKAGING WAS TO TRY TO CAPTURE ALL THE FUN, SOCIABILITY, AND THE WARM, ACCEPTING ATMOSPHERE OF THE CAFÉS."

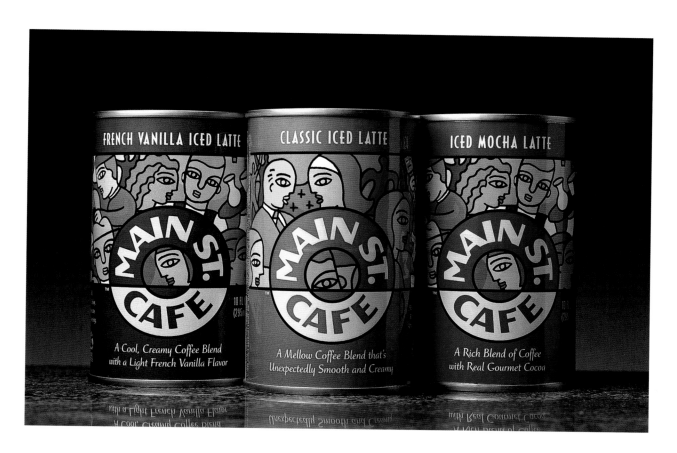

[above]

Initial sales of Main St. Cafe have been directly linked to the bold graphics, even though the can is not as preferable among consumers as bottled beverages in the same category. Despite that perception, once consumers picked up Main St. Cafe and actually tried the product, they ignored its glass contenders and purchased it again and again.

MURRIE, LIENHART, RYSNER ASSOCIATES
GALLERY

Old package

[right]

When a famous Chicago steakhouse introduced its legendary seasonings in the grocery aisle, the packaging just didn't communicate the bold qualities of the seasonings. MLR redesigned the packaging by combining a black back-drop with a copper brand identity, whimsical illustrations, and bold colors to create an authentic gourmet-looking item.

New package

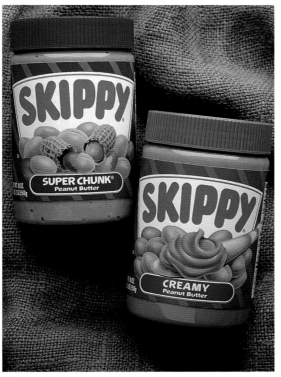

New

Old

[left and above]

As the leading brand in the peanut butter category, Skippy's management saw the need to define Skippy in contemporary terms, fostering Skippy's unique taste as the key benefit. MLR's objective was to meet this goal while retaining the strong visual equities of the brand.

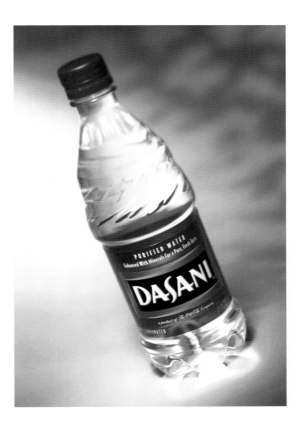

[left]

MLR created a multi-dimensional brandmark for Dasani that communicates cool and crisp attributes. The lightly tinted blue bottle and deep translucent blue label deliver the emotional promise that Dasani will satisfy your palette.

BRANDING
ᴀPROVINCE

ONTARIO 2000

BRAND BY LEAPFROG DESIGN

Creating a brand mark that represents a body of people, as opposed to a physical product or service, is tricky in itself. But developing a brand identity for a diverse government body is an overwhelming task—the branding cannot be politically motivated, it has to appeal across party lines, and still be aesthetically pleasing to the masses.

[THE CHALLENGE]

Leapfrog Design (Toronto, Ontario) was asked by the Ministry of Citizenship, Culture, and Recreation of the Ontario Government to undertake just such a project—create a millennium brand mark for the province. "We wanted some type of visual identity in order to separate or iden- tify the province of Ontario's initiatives in the millennium year," explains Fred Ross, executive director of the Ontario 2000 project. "We thought that something more unique than a simple word mark of the province was required and that led us to the decision to develop a brand."

Jean-Pierre Veilleux, president and creative director of Leapfrog says, "This mark is not intended to sell anything, so it's not branding in the traditional sense where you start with an image and you build a brand experience around the service or product offering. This is a 'feel good' mark to build a sense of pride in the province. It has to appeal to a very broad constituency— there are ten million residents in Ontario and it's very multi-cultural, so we had to pay attention to diversity and have something that satisfied all the different groups and not offend anybody."

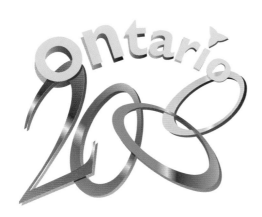
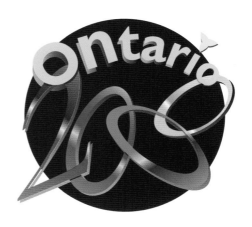
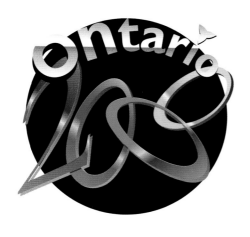
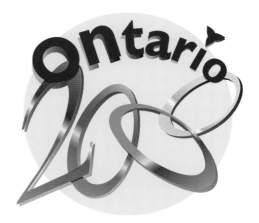

[above]

This bold and energy-laden execution focuses on portraying the dynamism and youthfulness of the province. However, province officials thought it was too loose—they wanted something a bit more conservative.

Probably the biggest challenge for the designers is that this brand must work in a variety of ways—the design must be flexible enough to be applied to merchandise such as T-shirts, hats, and jackets, while also working on government materials including stationery and even government vehicles. The criteria the Ministry brought to the table was very restricted. "It has to have a commemorative feel to it, but it couldn't simply be celebratory. It has to be recognized as a symbol of the millennium year, and it has to include the province's official flower, the trillium," Ross explains. "This is a once-in-a-lifetime event and it's fine to celebrate, but it's not just fireworks, party hats, and noisemakers. We were looking for something that wasn't too abstract because everybody had to get it, and it has to contribute to the overall physical appearance of anything it will be placed on."

Since there were so many provisions, it was important that Veilleux, who was the creative director on the project, work closely with the Ministry in developing the initial direction. "We spent long hours at the front end discussing philosophies and approaches, and visualizing how the brand would be applied," Ross recalls. However, he is quick to point out that the Ministry's involvement in the implementation of the mark was only to discuss ideas up-front, not to be involved in the actual design of the mark.

"I thought it was better for us to provide all of the information to Leapfrog and not restrict the creativity, so they could provide us with something that's exciting and dynamic. You have to be extremely careful no to over-direct creatives or otherwise you're going to end up with piecemeal design that is safe," he advises. "I was afraid the designers would say, 'It's not great, but it's the best we could do with all the restrictions.' I wanted everyone to buy in on the brand and think it's fabulous. Then we have a very successful design."

[DEVELOPING A STRATEGY]

With many of the objectives for the mark stated, Leapfrog explored many design directions. The designers adapted the typestyle from an existing tourism mark so there was a level of continuity, but veered away from the stately, conservative look. "The 2000 mark was intended to have a very animated and organic feeling. We wanted to give the impression of fireworks, but also have a natural feel, like a flower," Veilleux notes.

Colors were very important in the design process as well. "The colors instilled energy, vibrancy, and diversity, but more importantly, this could not be seen as a partisan mark," Veilleux says. "Every party in Canada has its own color—the conservative government that is now in power is blue; the liberal government is red; and the new democrats are green. So we couldn't design a mark that people would associate with a party—it had to be politically neutral."

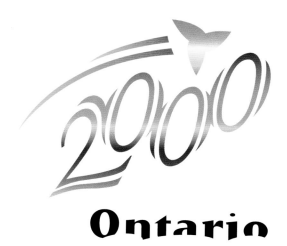

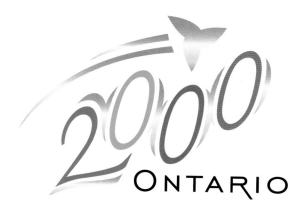

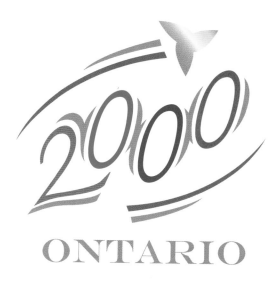

[above and left]
Since the trillium is Ontario's official flower, Leapfrog designers incorporated it into these designs. As Jean-Pierre Veilleux of Leapfrog recalls, "We wanted to portray the trillium as a shooting star that would represent Ontario entering the new millennium."

"YOU HAVE TO BE EXTREMELY CAREFUL NOT TO OVER-DIRECT CREATIVES, OTHERWISE YOU'RE GOING TO END UP WITH PIECEMEAL DESIGN THAT IS SAFE. I WAS AFRAID THE DESIGNERS WOULD SAY, 'IT'S NOT GREAT, BUT IT'S THE BEST WE COULD DO WITH ALL THE RESTRICTIONS.' I WANTED EVERYONE TO BUY IN ON THE BRAND AND THINK IT'S FABULOUS. THEN WE HAVE A VERY SUCCESSFUL DESIGN."

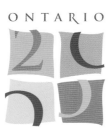

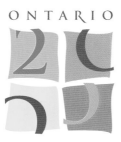

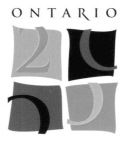

[above]
These loose renditions, reminiscent of a flag, suggest pride and belonging and puts emphasis on diversity through the use of different color combinations.

In fact, Ross adds, "If we had seen a logo that appeared to have a partisan visual identity, it wouldn't have been accepted." He also notes that this mark was intended to build unity within the government by promoting harmony among government workers, and to create a foundation for community governments within Ontario to build their own identities from the provincial brand. "We found that it was much more difficult than we had first envisioned in terms of the different requirements," he admits.

[IMPLEMENTING THE SOLUTION]

After presenting several rounds of comps, Veilleux was pleased that Ministry officials chose the design he recommended. "I liked it better than the others because it has a very soft and organic quality and we liked the fact that the lines forming the zeroes have the feeling of pyrotechnics, fireworks, and celebration. We wanted something that looks like a moment in time leading up to the celebration," he says.

Merchandise with the Ontario 2000 brand was rolled out in the spring of 1999, and Ontario residents were delighted with their millennium mark. In fact, Ross says, a bomber jacket that featured the logo on the entire backside was an instant hit with government workers who accounted for nearly one-hundred of the initial purchases.

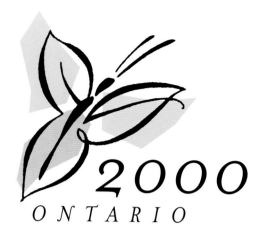

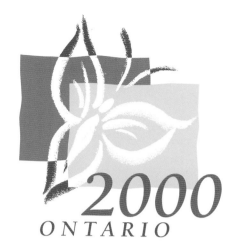

[above]
Leapfrog designers presented several
approaches that played off the
combination of a butterfly shape and
the trillium.

[above]
"This expression of forward
movement and energy is intended
to convey Ontario's economic and
cultural momentum entering the
new millennium and beyond,"
explains Veilleux.

This stately tourism mark for Ontario, although quite different from the eccentric approaches the designers implemented for the 2000 brand, served as a point of reference. In fact, the same typeface was ultimately used to maintain a visual consistency.

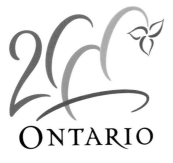

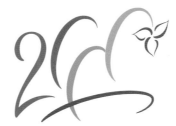

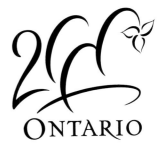

[above and right]
The final brand visually links all the essential elements together: Ontario, 2000, a trillium, political diversity through the colors, and the celebratory tone to welcome the new millennium. The design is intentionally flexible enough to be used in black-and-white, as well as reversed out of a black background

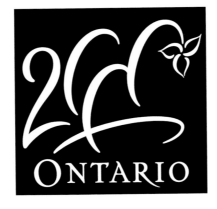

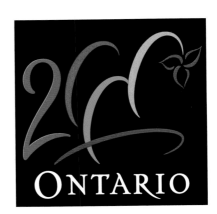

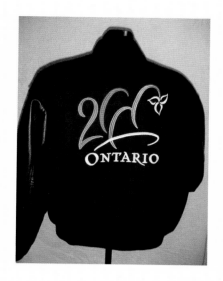

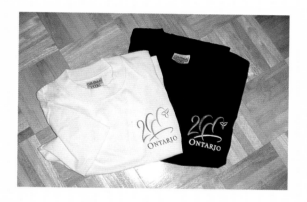

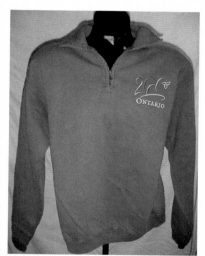

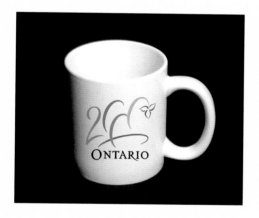

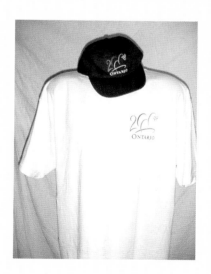

[left and above]
Merchandise with the Ontario 2000 brand has been a hot-seller in the province since its introduction.

[2]

MICHAEL OSBORNE, PRINCIPAL OF MICHAEL OSBORNE DESIGN, SAN FRANCISCO

Brand revitalization is tricky for a number of reasons. It puts the designer in the position of trying to make the most of established equities, trying not to ruin or eliminate elements that work, and trying to make what works, work better. The goal is not to reinvent the wheel—just to outfit it with a new pair of hub caps.

Equities are characteristics of a brand that consumers recognize and often reflect **ASPECTS OF THE DESIGN THAT MAKE A PRODUCT SUCCESSFUL**. Frequently, a redesign is executed on a brand that is working very well, but the redesign is done in an effort to "keep up with the Joneses," in reaction to new trends in the marketplace, or to keep one step ahead of the competition.

Companies also decide to revitalize their brands when the design or positioning is not working in the market. The product has launched, but only with partial success. Things may have changed in the marketplace, or competitive products stole the spotlight.

Designers are in a very precarious position when charged with the task of redesigning an existing brand. The goal is to keep the good things and build on them, but sometimes determining what is good and what is bad is tricky. Doing the **LEGWORK** and **RESEARCH** to back up your judgments is very important.

We approach redesigns in an evolutionary manner. One technique is to get clients to tell us, on a scale of one to ten, how much they want to change their brand. One being very close to the existing brand, and ten is a complete redesign and change of all the brand elements, including the name, the logo, type style, and color. We try to get the client to answer this question by providing us with a **RANGE** within one to ten, not just one number.

If the client determines a range between three and four, our design presentation will show them concepts in the two, three, four, five, and six categories to show them a variety of possibilities—options which keep the existing brand equities, capitalize on what is working in the brand, and add to it little by little until, eventually, it looks new.

It is a bigger challenge to update a brand only slightly, as opposed to radically evolving a brand. If you radically change it, you have a bigger sandbox, there are more design options. It is much harder to stay within the one to two range and be successful. The consumer may not even notice until you put the old brand presentation and the new one side by side. This is the ultimate goal—not to lose your current franchise while simultaneously **ADDING VALUE**.

REDESIGNING
OR UPDATING
A WELL-KNOWN
BRAND

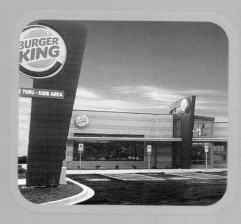

CREATING
A WORLDWIDE STANDARD

AVON
BRAND BY O&J INC. DESIGN

Over the past century Avon has established itself as not only a leader in the cosmetics industry, but as a corporate powerhouse when it comes to supporting women's issues globally. To support this position, the company wanted to update its brand image and reinforce Avon's vision as "the company that best understands and satisfies the product, service, and self-fulfillment needs of women globally."

Regina Milano, Avon's senior manager of global communications says, "We wanted a tagline that would capture the company's vision in a few words. Our goal was to speak to everything that Avon means to women—the products, personal service, philanthropic activities, and being a great place for women to work." One of the original phrases proposed was, *In the company of women.* In English it has both literal and subjective meanings, but it was difficult for people to explain in other languages.

The next tagline—*The company for women*—stuck. "It summed up who we were and everybody rallied around it right away," Milano admits. "It is a natural evolution of what the company has meant in the lives of women over a 114-year history. Nobody else can make this claim."

With the tagline established, a new brand identity had to be built around it. O & J Design Inc., of New York City, was commissioned to fulfill the design of the brand. O & J Design already had a well-established relationship with Avon. They had been involved in a number of corporate projects, one of them being Avon's Global Vision Program. "The role of this program was to heighten the awareness of the Avon brand and its success in serving women worldwide; this differentiated Avon from other companies," explains Barbara Olejniczak who co-owns and operates O & J Design with her husband, Andrzej. "But," she adds, "it was confusing to have a program separate from the identity, so Avon decided to simplify all of this by integrating the Global Vision concept with its new brand identity to create a stronger voice that will be implemented worldwide."

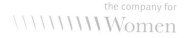

The designers experimented with several graphics that could represent women and, ultimately, Avon. The first two taglines (top) represent energy and warmth. The next two designs incorporated curves for women and strength, and the hands in the last design illustrate support and friendship of women.

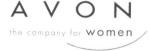

These tagline sketches explored the possibilities with the existing corporate typefaces, Futura and Times Roman. "We experimented with type weight and kerning to achieve a different emphasis for each. Line elements were also used to create positive energy around the tagline," says Andrzej Olejniczak of O & J Design Inc.

Using a profile of a woman's face in these designs helps reinforce the tagline. The company for women.

[DEVELOPING A STRATEGY]

O & J did an in-depth design exploration of the new tagline, presenting a study in different graphic elements, type treatments, and color schemes. Although many solutions could have worked, Avon representatives already had a graphic element in mind—the popular lipstick stroke that had been used in the past. "It had significance for people within Avon, and it carried a lot of equity," Andrzej explains.

Milano adds, "The brushstroke or lipstick swash harks back to a design that was very popular. It looked as if someone underlined the word Avon with a tube of lipstick. It was whimsical and fun."

Once the design direction was chosen, O & J's creatives saw more opportunities to distinguish Avon from other beauty companies. "The previous identity was rather limited in scope and didn't have a full visual vocabulary. We wanted to remedy this and create a visual system that is truly inspiring," Andrzej notes.

"These soft hues with very delicate, circular shapes create a very distinct and unusual backdrop to promote the beauty products," Barbara adds. One of the challenges O & J faced when working with such a huge corporation was integrating a single brand identity across the board—from cultural barriers, since Avon has operations all over the world, to the many philanthropic activities sponsored by Avon that need to carry the corporate look in promotions. All these special programs were previously using separate images and identities, so O & J—which is known for its comprehensive standards systems—created a standards manual for Avon to be used by all of its associates and subsidiaries. It demonstrates how certain communications should look, how the logo and tagline should be used, what colors are available, and more.

"Some of the programs didn't really have logos, so this whole new wave of changes inspired small groups within Avon to upgrade themselves. Our goal was to distinguish one from another, but they still need to use this idea of the artistic, freehand, brushstroke," Andrzej explains. "We are dealing with a lot of issues, and a lot of different people, so it's an educational process to make them believe that you have to use the same typeface, and you have to work within the color palette. This is how Avon has to look. This is its image."

Barbara adds, "We worked with the people at Avon very closely and we advised them that they needed to streamline the number of communications and the different programs' identities. As designers we believe in identities that give people flexibility. That's why we created the extended color palette and other elements to allow people to be creative with their communications, but stay within the overall look. Now everybody is talking in the same visual language."

"OUR GOAL WAS TO SPEAK TO **EVERYTHING** THAT AVON MEANS **TO WOMEN**—THE PRODUCTS, PERSONAL SERVICE, PHILANTHROPIC ACTIVITIES, AND **BEING** A GREAT PLACE FOR **WOMEN TO WORK."**

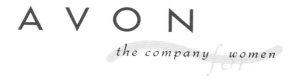

[above and left]
"Flowers are often associated with women and beauty. When studied closer, a woman's figure can be seen," notes Andrzej.

[above and left]
These were two of the tagline design variations that O & J devised. The simple curves and the emphasis on the words *the* and *for* give the left tagline a unique rhythm. The other tagline's calligraphic feel (above) makes it very elegant.

"AS DESIGNERS WE BELIEVE IN IDENTITIES THAT GIVE PEOPLE FLEXIBILITY. THAT'S WHY WE CREATED THE EXTENDED COLOR PALETTE AND OTHER ELEMENTS TO ALLOW PEOPLE TO BE CREATIVE WITH THEIR COMMUNICATIONS, BUT STAY WITH THE OVERALL LOOK. NOW EVERYBODY IS TALKING IN THE SAME VISUAL LANGUAGE."

Avon chose not to translate the new tagline "because we would never capture the emotional nuances we want to convey in every language," Milano explains. "But when people see the logo, the tagline, and the brushstroke together, they understand that it's Avon, and they get the emotional impact of what we mean to women everywhere in the world."

Since the new identity has been introduced internally, it has been very well received and O & J continues to work with Avon to ensure it is properly implemented. Milano says of the working relationship with the design firm, "They make it their business to really understand us and our culture. They looked at all angles of the application and how it will be used, and what we came up with was a result of a lot of dialogue back and forth. Our new design is bold and it certainly jumps out at you."

[left]
Ultimately this is the design the Avon representatives wanted to use because of the familiar lipstick swash. It's used on all of Avon's corporate communications including stationery and business cards.

GLOBAL EXCHANGE

AVON the company for women

AVON
RUNNING

Global Women's Circuit

AVON the company for women

AVON the company for women

AVON
worldwide fund for
women's health

AVON the company for women

AVON the company for women

[above]
Since Avon sponsors so many programs for women, O & J created logos for each event. To give them a common feel, the designers incorporated the hand-painted brushstroke.

[left and below]
To ensure proper usage of the new brand identity, O & J developed Avon's Worldwide Corporate Identity Standards manual. It's an extensive exploration containing examples of how the new Avon brand identity should and should not be used.

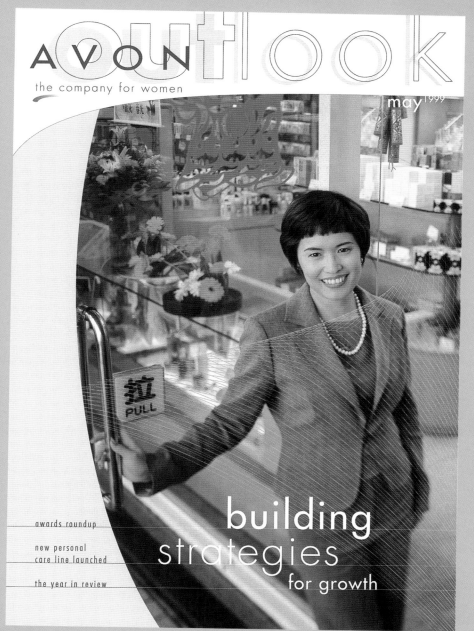

New

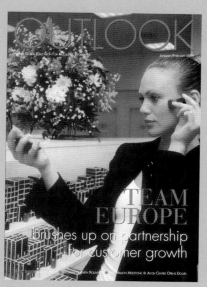

Old

[above and left]
O & J redesigned Avon's corporate magazine, *Outlook,* using the new tagline and logo. The old cover looked very dated and plain, compared to the new layout which is much more open and flowing.

RECOGNIZING
A NEW CONSUMER

<div>

BUGLE BOY
BRAND BY BC DESIGN AND COLE & WEBER

</div>

Building a brand based on its price category is nothing to be ashamed of, according to designers David Bates and Mike Calkins, principals of BC Design in Seattle. Working with the advertising agency Cole & Weber (also based in Seattle), that is exactly what they did when they were asked to redesign the Bugle Boy clothing brand.

"We were trying to be up-front with the prices and trying not to emulate other brands," says Bates. "We said, 'Don't try to hide the fact that you're a price-point driven store, embrace it'," Calkins adds. "There's a huge opportunity there that's fairly untapped. Bugle Boy has been able to be a low price brand without having a stigma attached to it."

Founded in 1977, Bugle Boy has changed dramatically since its days as a young men's fashion brand. The company now makes casual clothing for women, men, young men, and boys. Bugle Boy had stopped advertising in many markets and, as a result, consumers forgot about the brand altogether.

[THE CHALLENGE]

According to Suzanne Baird, Cole & Weber's account supervisor, "The people we talked to in focus groups reflected on the Bugle Boy brand nostalgically—they said they haven't seen it lately and they couldn't quite pin down a Bugle Boy personality," she recalls. The image those surveyed most often recalled was the classic commercial from the late '80s with the woman pulling her car alongside a young man walking down the street and saying, "Excuse me. Are those Bugle Boy jeans you're wearing?"

"OUR PHILOSOPHY IS THAT EVERY POINT OF THE BRAND THAT TOUCHES THE CONSUMER MUST DELIVER THE SAME MESSAGE—WHETHER IT'S THE STORE ITSELF, THE MERCHANDISE IN THE STORE, ADVERTISING, A WEB SITE, TELEVISION, ETC. ANY MESSAGE THAT REACHES THE CONSUMER MUST DELIVER THE SAME BRAND IMAGE."

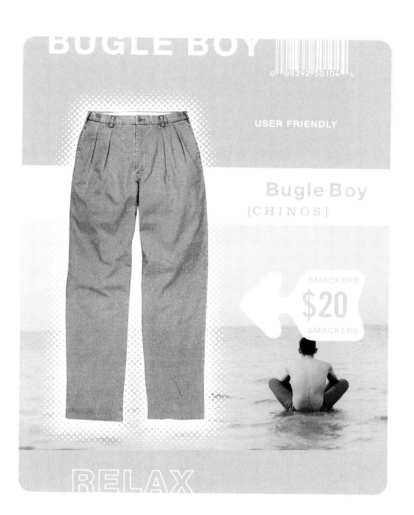

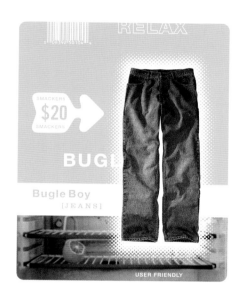

[left and above]
In BC Design's first round of concepts they presented to Bugle Boy reps, the designers incorporated actual visuals of the clothing for the in-store posters. "We wanted to incorporate the actual clothes in the visuals, so it would be less fashion-driven, more utilitarian—kind of like a hardware store, but try to be tasteful at the same time," designer Mike Calkins explains. However, Bugle Boy thought the images were too clothing specific—they wanted something that spoke to the lines of clothing in general.

"I swear every man in America can quote that commercial to a T," notes Baird. Although that ad has successfully lingered in many peoples' minds over the years, it did not really speak to the wider array of end users of the product—moms, dads, and young boys—nor communicate the low-price message.

Ron Klein, creative director at Cole & Weber relates, "We found this to be a challenge—to take a brand that everybody remembers because of that one commercial and translate it to what it truly is today. We had to overcome a perception that has taken on a life of its own."

[DEVELOPING THE STRATEGY]

"Bugle Boy wanted a firm brand identity that would extend into all facets of the company," Klein says. "Our philosophy is that every point of the brand that touches the consumer must deliver the same message—whether it's the store itself, the merchandise in the store, advertising, a web site, television, etc. Any message that reaches the consumer must deliver the same brand image, especially today because everything is so fragmented."

Before testing the focus groups, Cole & Weber executives were told by Bugle Boy that the target market for their merchandise is moms because they purchase the clothes for their husbands and children. "We kind of took them on their word and were fairly certain that moms were indeed the key audience, but we wanted to do a disaster check among dads and boys to make sure we weren't alienating them since they are the end-users," recalls Baird. The focus groups were conducted with four groups of mothers, two groups of fathers, as well as friendship pairs of boys. "When you get a group of teenage boys together in a room, they do a lot of flaunting and bragging and they aren't very truthful or real. So, instead, we put a boy and his friend together and you get much more honest responses than when they're in front of a bunch of their peers," Baird explains.

The research indicated that the brand had a lot of potential, especially with mothers. "We learned that we had some real positive, functional qualities that appealed to moms with the clothes—comfort, durability, casualness, and a value for the money. But as far as involvement with the brand, there wasn't a tangible personality. There was no clear brand identity associated with Bugle Boy," she adds. "So because of the lack of involvement with the brand, it was only being purchased to solve a functional problem—they were just looking at price and quality as a way to evaluate it, but we all know that most clothing purchases aren't based on such rational decisions. We saw that as a real problem."

"Ikea was an easy model for us to reference because it is respectable, and you can find something pretty cool for a reasonable price. That's where we came up with the user-friendly notion, because when you go to Ikea, everything from the way you park your car, to how you walk through the store, is designed for customers' convenience," Calkins adds. "So we started playing with that idea, and we came up with using arrows in the design."

"WE FOUND THIS TO BE A CHALLENGE TO TAKE A BRAND THAT EVERYBODY REMEMBERS BECAUSE OF ONE COMMERCIAL AND TRANSLATE IT TO WHAT IT TRULY IS TODAY. WE HAD TO OVERCOME A PERCEPTION THAT HAS TAKEN ON A LIFE OF ITS OWN."

[above]

The second round of concepts that BC Design presented to Bugle Boy had more of a graphic approach, but the client asked the designers to come up with another direction that would be more photography-driven, and again without focusing too much on specific pieces of clothing, so the posters would not have to updated every season.

BUILDING A BRAND BASED ON ITS PRICE CATEGORY IS NOTHING TO BE ASHAMED OF...WE SAID, 'DON'T TRY TO HIDE THE FACT THAT YOU'RE A PRICE-POINT DRIVEN STORE, EMBRACE IT!'... BUGLE BOY HAS BEEN ABLE TO BE A LOW-PRICED BRAND WITHOUT HAVING A STIGMA ATTACHED TO IT."

[above]

The old Bugle Boy logo had been around for many years. but it did not have a personality and it did not communicate any positive brand attributes. BC Design used the same sans serif typeface that Bugle Boy had always used. but they put a different spin on it. putting the Bs back-to-back.

Because the designers understood the importance of appealing to moms without turning off the kids, their graphics were intended to strike a chord with the end-users as well. "They were saying that mothers were basically their prime target audience, but let's face it, either the kid's going to wear it or not," Bates says.

"It's true to an extent, that mothers buy it. That's fine, our goal was to try to keep that customer even if it's only for the price. But we were also saying, 'What if you made it hip enough to attract people that could afford to shop somewhere else without alienating the original customer?' That's the approach we've been taking with the design of the brand," Calkins notes.

Their first concept was to incorporate people wearing the clothing in the design, but the client rejected that approach because it would have to be updated too often as the clothing lines change in styles and seasons. "It became a logistics thing," according to Bates. "This sign has to be up for six months so they didn't want specific items of clothing in the materials."

After a couple more design rounds Bates and Calkins came up with a more generic approach. Instead of focusing too heavily on the clothing, they used generic-looking, action-oriented photos and created designs that worked with the photos. "We were trying to pull colors out of the photos," Bates says. "We didn't want to have different colors for the departments because if the photos change, the colors wouldn't go with it, so we let the photography drive the colors."

The designers also created a new logo for Bugle Boy, but they had to maintain some of the old image. "Part of it is their heritage," Bates recalls. "They want to change, but they don't want to lose the brand equity they've built. They had this san serif uppercase font that they've been using since the '80s, and we wanted to use some of that but downplay it, and the upper- and lowercase seemed like a natural because it wasn't so serious."

"We wanted it to be hyper-generic on purpose—going back to the original idea that it's user-friendly clothing, not necessarily fashion clothes. That's why we picked Helvetica," Calkins adds. "It's a standard. The whole idea is that everything is really unassuming about this place. We were walking a fence—understated sophistication, but unassuming."

The designers worked closely with Cole & Weber to make sure they were all on the same page, bouncing ideas off one another. The ad agency tested the initial designs with focus groups and according to Baird, "Women liked it. The photography captured the moment, they liked that the prices were prominent, and they thought the arrows would be helpful to find what they're looking for. They liked the fact that it was everyday scenes of everyday people—there was no pretension."

[above and right]
For the third round, the designers focused on the "user-friendly" concept. "We did it like it was a key to a map. The clothes are highlighted, but again it was too specific to the clothing lines. They wanted every poster to be extremely flexible," David Bates explains.

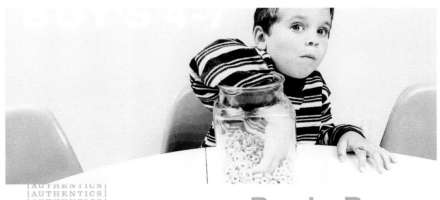

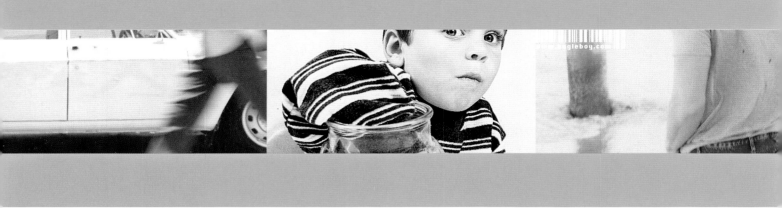

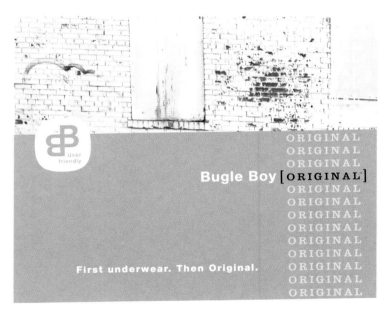

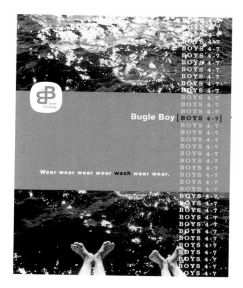

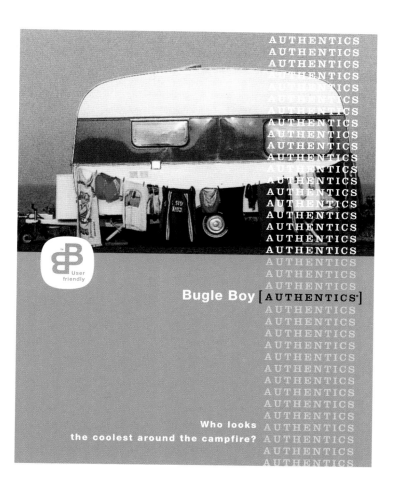

[opposite, above, and left]
Eventually, Bugle Boy harked back to an idea that was in BC Design's original pitch, focusing the imagery more on a lifestyle rather than the clothing itself. The designers worked closely with writers at Cole & Weber who came up with catchy taglines. "We wanted these posters to look progressive, so design-wise, it's targeted to a younger person," Bates explains. He and Calkins pulled colors out of the photos for the background colors. They also went with a softer, muted color palette because they did not want the graphics to be loud.

BRANDING
FOR THE BIRDS

KAYTEE BIRDSEED
BRAND BY MURRIE, LIENHART, RYSNER ASSOCIATES

Turning a relatively unheard of product into a popular brand through a strategic branding and marketing campaign is a typical success story. But turning a $10 million business into a $150 million business in just six years is almost unheard of. But this is no fairly tale. This is the true story of KayTee birdseed, based in Chilton, Wisconsin.

In 1986, KayTee was going through an identity crisis—the company executives knew they had a great product, but they didn't have a solid brand or market strategy to promote it. Tom Ramey was hired as vice president of sales and marketing to help re-focus the company and lead the marketing and sales efforts.

"This was a very small company where the package design was done in-house, and they thought it looked great because it all looked the same," he recalls. "I said, 'Being the same is not always good. You do want a nice, uniform look for shelf visibility and merchandising reasons. But the value-added, caged birds product sells for 40 percent more than the standard feed, and you can't tell the difference between them.' They weren't communicating the positioning of the products."

Ramey soon realized as well that this problem wasn't unique to KayTee—it was an industry pitfall. KayTee needed to pump up its brand identity through the packaging, and do it before the competition caught on.

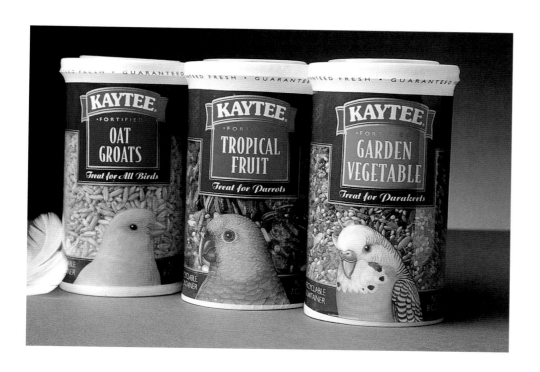

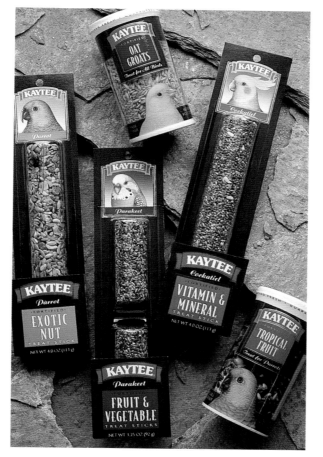

[left]

When KayTee birdseed was updating the look for its caged birdseed varieties, company representatives thought the packaging needed to be more accessible and user-friendly so they came up with the plastic canisters. MLR designers then incorporated photos of the birds on the packaging so consumers could easily identify which birdseed they needed.

"THE CONCEPT WAS TO SELL THE LINE AND MANAGE THE SHELVES SO THAT WE WOULD OUT-MANEUVER THE COMPETITION."

[DEVELOPING A STRATEGY]

The first thing Ramey did in his new position was conduct focus groups with bird owners. "We started talking to them about bird ownership and we were hearing that they are very involved with their birds. They watch TV with them, they eat with them, they wrestle with them, and they even talk with them," he explains. Ramey also did a quantitative study to determine how many people have birds, what types of birds they have, how they feed them, and where they buy their birdseed. The design firm of Murrie, Lienhart, Rysner Associates (MLR) of Chicago was then brought in to design a brand image that would promote and nurture the perception of the owners' familial relationships with their birds.

The packaging itself became a factor in the brand design to make it more accessible and identifiable to consumers. Ramey says, "Most of our product was in poly bags, but we found evidence that people liked to see the food." So their decision was clear—literally. Clear packaging was selected for all of KayTee's caged bird treat canisters. This was an industry innovation.

[IMPLEMENTING A SOLUTION]

To distinguish itself in the category, the marketing team, along with creative director and MLR principal Shel Rysner, decided that it would be in KayTee's best interests to actually show pictures of the birds on the packaging. Under Rysner's direction, the designers developed a number of executions addressing the different platforms, which were then tested with consumers. "We went to the malls and showed people the design and it got the reactions and intent to purchase we were looking for on each of the packages," Ramey relates.

"The upshot of this is that we learned the potency of the brand on the package and we started segmenting the brand, creating bird-specific packaging," Rysner recalls. "The concept was to sell the line and manage the shelves so that we would out-maneuver the competition." The packaging included colorful illustrations of the specific birds for which the seed was intended, so consumers could see their bird and identify with the product.

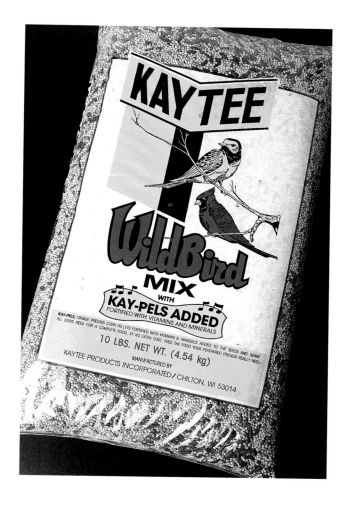

[left]

KayTee had an image problem with its wild birdseed varieties. The packaging was outdated and it was not distinguishable on store shelves.

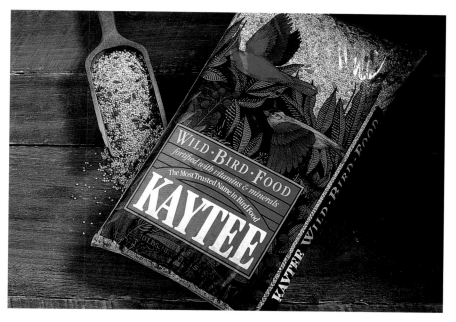

[left]

To make the wild birdseed stand out from the competition, the designers brightened up the packaging with colorful illustrations of wild birds, and the KayTee name was given a much bolder presence.

As Ramey puts it, "It's like high-involved dog owners who like to see their dog on the package. We wanted to take advantage of that in our advertising and packaging."

The response to the new packaging was immediate. "Our selling was better because we were going to the trade and telling them who the consumer is, what they're looking for, and giving them the solution," Ramey explains. "It's also an industry that I call 'high-touch, low-tech.' The retail store clerk has a big influence on what the consumer will purchase. People will go to pet stores to make a purchase because someone is there to answer their questions. We used the package as a selling device and other materials were provided to the stores to help educate the retail store person."

And, of course, the key reason KayTee was such a hit with consumers is because "the package looked great," Ramey says. "We got more distributors to take it on, and the velocity in retail stores increased as consumers picked it up in greater numbers."

He attributes the success of the brand to the close working relationship he had with Rysner and the designers. "The more your design company is a partner with you, the more successful you're going to be. Shel was always a member of our team as we developed new products. Branding is more important than advertising because in the absence of advertising, it's the only communication you have with consumers," Ramey concludes.

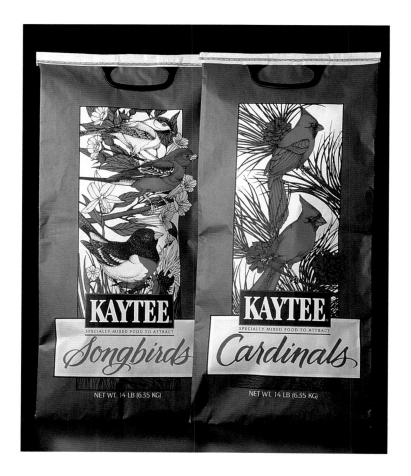

"BRANDING IS MORE IMPORTANT THAN ADVERTISING BECAUSE, IN THE ABSENCE OF ADVERTISING, IT IS THE ONLY COMMUNICATION YOU HAVE WITH CONSUMERS."

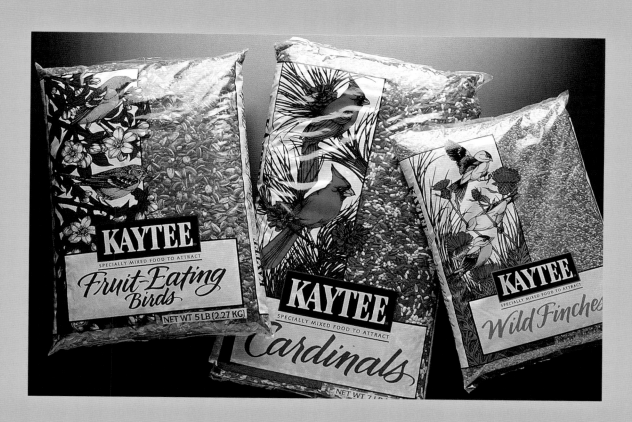

[opposite and above]
Since many people consider outdoor birds their pets, MLR designers played up the concept by personalizing the different birdseeds for particular birds, such as cardinals, finches, and songbirds.

REDESIGNING A FAST-FOOD GIANT

BURGER KING

BRAND BY THE STERLING GROUP AND FITCH

With little modification made to the Burger King brand mark in nearly 25 years, Burger King Corporation (BKC) decided the brand was in need of an overhaul. The corporation wanted to create a powerful and consistent brand image that would be communicated to all consumers in all touch points with the brand—logo, signage, restaurant design, and packaging. In order to do this, BKC sought to define and articulate a single global brand essence, which would then be injected into all elements of the brand.

"Burger King wanted us to focus on the bun logo, but their objectives were really to develop a high impact brand mark to reinforce the new brand essence," says Marcus Hewitt, managing partner and creative director at the Sterling Group, the firm commissioned to work with BKC's brand team to redesign the brand. "They wanted it to be contemporary but not trendy, and infuse more energy into the brand. The old brand identity is very corporate and quiet, and everything flows in a straight line. The type is round, the bun is round, the yellow and red are warm and soft colors— it needed more impact," he adds.

[DEVELOPING A STRATEGY]

The Sterling Group and BKC's brand team introduced several rounds of logo explorations, including design executions with flames to accentuate Burger King's signature "flame broiled" cooking technique and experimenting with different type treatments and colors. "We didn't want to add too many other elements. I think it's a delicate balance with a brand mark like this because you see it on so many products—it's everywhere and you don't want it to be too fussy," Hewitt recalls.

Used with permission from Burger King Brands, Inc.

[left and below]
Burger King's old brand identity had not been updated in nearly 25 years. "It's an incredibly well recognized brand, but it's very corporate and it doesn't live up to the quality of the restaurant," says Marcus Hewitt, managing partner and creative director at the Sterling Group, the firm hired to redesign the brand.

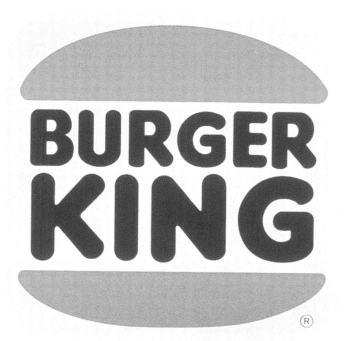

Used with permission from Burger King Brands, Inc.

The designers also introduced a new color to brighten up the logo which traditionally was only represented with red and yellow. "It was natural to add another color. When you look at it now without the blue, it looks like a color is missing," he notes. "The world where that brand mark was operating has moved on and we looked at the competitors which had more elaborate logos with more color and action."

The designers retained the brand mark's bun image, which is a strong communicator of the brand's appeal, and enlarged the type so that it extended beyond the bun, to convey the idea of a bigger taste and reinforce the size of the Whopper sandwich. The slightly tilted image and type also convey a sense of energy and motion. "We were building on what they had, but it was a significant change. We refined the type, we kept some of the curves and added some sharper edges, and every element is working better than it was," the designer says. "This is a massive franchise business and BKC couldn't afford to have people not recognize the brand."

[IMPLEMENTING A SOLUTION]

With a brand design established, Fitch, an international design and business consultancy, was called in to develop the three-dimensional aspects of the brand, including interior and exterior building design and trade dress elements, and signage of the Burger King restaurants. Consumer research, conducted by BKC and Fitch, revealed underlying social aspects of the fast-food experience that needed to be addressed. "The research helped us design the experience of the brand—how people would actually like to flow through the space, not just how they would like it to look," explains Jon Baines, associate vice president at Fitch.

Since the Burger King franchises are all owned and operated by different people, the interiors of the restaurants reflected that, which posed a challenge to the Fitch creatives. "In the past, the franchisees were given carte blanche as far as what the inside of their restaurants looked like, so they all looked different," Baines says. "One of the main ideas that has been introduced is that the core experience at Burger King should be consistent." So it was decided that the places where the customer comes in contact with the food in all restaurants should be the same, in theory making this experience consistent across the board.

A major focus of the interior design is a streamlined layout for the customer ordering process. Separate areas are now defined for order placement and pick-up. In addition, menus have been redesigned to display items only during the time of day when they are available.

Another concept the creatives discovered from the consumer research is how people perceive their dining experience. "People like to get their food fast, but they don't necessarily like to eat it fast when they're dining in. They like to relax," recalls Baines. So several kinds of seating areas have been incorporated into the restaurant design, including bright open areas geared to large groups and families, and areas for more intimate dining. In addition to the tables themselves, the

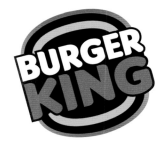

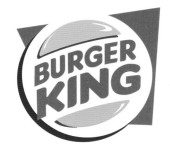

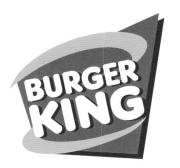

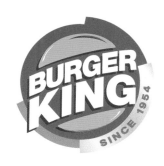

For most of the initial sketches, the designers experimented with the type and bun design, giving the brand mark a more animated quality to create energy and impact. They also introduced additional colors to complement Burger King's trademark red and yellow.

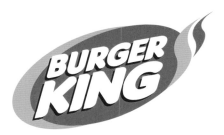

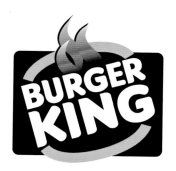

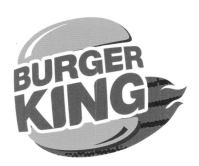

Used with permission from Burger King Brands, Inc.

"Some of the themes we looked at included adding flames because of the equity established with Burger King's 'flame-broiled' burgers," Hewitt recalls. Ultimately it was decided that the flames would make the brand mark look too busy.

environment is also a factor. "In many fast-food restaurants you see huge posters promoting different items in the dining area. We learned that people don't want to be reminded about what they may have missed in the ordering process once they have their food in front of them," Baines explains. In addition, strategic, focused lighting also helps to create distinct dining atmospheres.

The drive-thru experience has also been streamlined to the customers' advantage. Pre-menus at drive-thrus often look different than the ordering menu, so when the customer pulls up to order they cannot find the specific item they want to order. To alleviate this problem, the pre-menu is exactly the same as the ordering menu, and order confirmation screens reassure consumers that the order is right.

In addition, Burger King designed a transparent bag so people can see what is inside of it without having to open it up and check, oftentimes holding up the drive-thru line. They even went one step further—they developed a panic button that customers will be able to drive up to and use if something is indeed wrong with their order. "It's a great idea because they're not holding up the line and it's a reassurance factor to the customer," Baines notes.

To give new and existing restaurants a distinctive exterior trade dress, Fitch designed a blue sculptural element which will be retrofitted to existing restaurants. "The blue element, together with the new site signage, introduces the new Burger King trade dress," Baines says.

The new brand identity helps Burger King achieve competitive differentiation by creating a design that is in direct correlation with what consumers desire from a fast-food restaurant. Burger King will be rolling out the new brand identity in its restaurants in the coming years. So far, consumer response has been tremendously positive, translating to strong gains in sales and traffic at the restaurants currently employing the new look and feel.

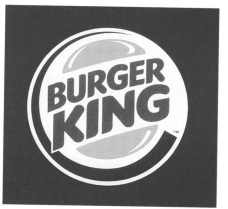

Used with permission from Burger King Brands, Inc.

[left]

BKC's creatives, along with Sterling, came up with this brand execution. It marries the best of the old with the new, and it exudes a much bolder presence with the enlarged type exploding out of the bun to convey the idea of a bigger taste.

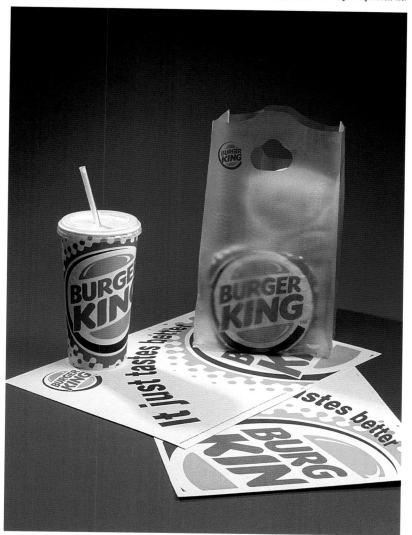

Used with permission from Burger King Brands, Inc.

[left]

All of the packaging, including the new clear-view bags that allow customers to see their orders, focuses on the new brand mark. The designers also incorporated red and blue pixelated shapes that surround the brand, exuding a sense of either radiating heat on items such as burgers and fries, or effervescence on soft drink cups.

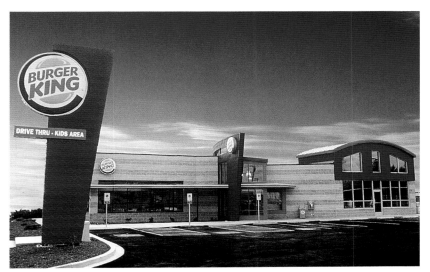

Used with permission from Burger King Brands, Inc.

[left]

The new Burger King trade dress was introduced in Reno, Nevada, at this newly-built restaurant. To incorporate the trade dress to existing restaurants, the blue "fin" that protrudes by the entrance will be retrofitted to those buildings in addition to incorporating the new signage.

Used with permission from Burger King Brands, Inc.

[left]

The open floor space, designed by Fitch, was created to accommodate seating for groups of all sizes. The corner booths provide a more solitary eating experience.

"THE RESEARCH HELPED US DESIGN THE EXPERIENCE OF THE BRAND—HOW PEOPLE WOULD ACTUALLY LIKE TO FLOW THROUGH THE SPACE, NOT JUST HOW THEY WOULD LIKE IT TO LOOK."

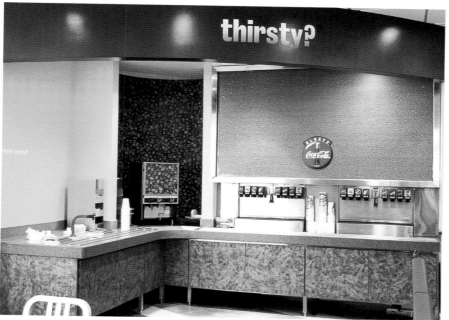

Used with permission from Burger King Brands, Inc.

[left]

The drink pick-up area was developed for customer convenience. The counter space was designed so trays could easily slide over it, and the open area allows customers to help themselves to refills.

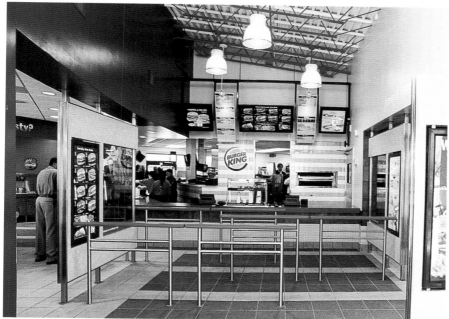

Used with permission from Burger King Brands, Inc.

[left]

The consumer ordering area is designed to keep people moving through the line by conveniently placing images of the food items in front of them so they can decide what to order before they get to the counter.

TURNING
A NAME INTO A BRAND

SUTTER HOME
BRAND BY MICHAEL OSBORNE DESIGN

For more than 50 years Sutter Home has been providing American consumers with a variety of affordably-priced wines. In 1947, Mario Trinchero took ownership of the winery, and throughout the '50s and '60s it was a "mom-and-pop" organization, sticking to the wine basics—selling reds and whites from a little winery in Napa Valley. In the early 1970s, though, things began to change. Bob Trinchero, the eldest son of Mario, began experimenting with Zinfandel wines, and created a light-colored wine with a slightly pinkish color and called it Oeil De Pedrix which means "eye of the partridge." Although this new wine did not sell well at first (only 2,000 cases the first year), according to Rob Celsi, Sutter Home's brand manager, the sweet-tasting wine was the beginning of something big.

In 1972, the Bureau of Alcohol, Tobacco, and Fire Arms informed the Trincheros that they had to call the wine what it really was, so they named it white zinfandel. By the 1980s, Sutter Home was selling so much of their wine—far beyond anyone's expectations—that they decided it was time for a new logo for the Sutter Home varietals. The Trincheros contracted with a local designer who came up with the stacked word mark, which has been used ever since. "Little did anyone know how important that brand would become," Celsi says. The label evolved slowly over the years, but by 1995 the competition was changing the landscape.

1993 CALIFORNIA
WHITE ZINFANDEL

VINTED AND BOTTLED BY SUTTER HOME WINERY INC.
NAPA, CALIFORNIA 94589 BW 5525
ALCOHOL 9% BY VOLUME

[left and below]

By 1985, Sutter Home was a successful contender for leadership in the wine category, so the company decided it was time for a new logo. A local designer came up with the stacked word mark, which changed very little over the years, as you see here. It was not until the mid '90s that the company embarked on a new brand identity to re-establish itself as a leader in the wine industry.

1992 CALIFORNIA
WHITE ZINFANDEL

VINTED AND BOTTLED BY SUTTER HOME WINERY INC.
NAPA, CALIFORNIA 94589 BW 5525
ALCOHOL 9% BY VOLUME. CONTAINS SULFITES

Sutter Home Winery has been owned since 1947 by the Trinchero family, whose tradition of producing quality wines has made Sutter Home a favorite of wine lovers. This light, semi-dry wine has an appealing salmon color, fresh, berrylike aromas, and lively, fruity flavors. Serve it chilled as a refreshing aperitif or with lighter meals.

Customers with questions or comments about Sutter Home wines may call 707-963-7664, M-F between 8 a.m. and 4 p.m. PST.

GOVERNMENT WARNING: (1) ACCORDING TO THE SURGEON GENERAL, WOMEN SHOULD NOT DRINK ALCOHOLIC BEVERAGES DURING PREGNANCY BECAUSE OF THE RISK OF BIRTH DEFECTS. (2) CONSUMPTION OF ALCOHOLIC BEVER-AGES IMPAIRS YOUR ABILITY TO DRIVE A CAR OR OPERATE MACHINERY, AND MAY CAUSE HEALTH PROBLEMS.

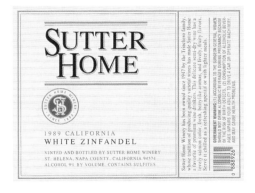

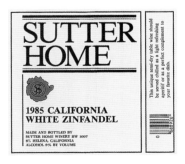

"THIS COMPANY IS REALLY GOOD ABOUT KEEPING THEIR FINGER ON THE PULSE OF THE MARKETPLACE — KEEPING THEIR BRAND UPDATED ON A REGULAR BASIS. YOU CAN'T STAY THE SAME TOO LONG IN THIS INDUSTRY BECAUSE YOU'LL GET LOST IN THE SHUFFLE."

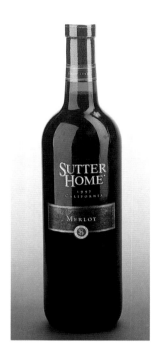

In 1995, Sutter Home updated its brand and created a clear, pressure-sensitive label. At the time, it was clearly distinct from other wines on the shelf.

Up to that time, Sutter Home's white zinfandel was being sold in a green bottle. "After a while, the competition—which had scoffed at Bob's invention of white zinfandel—stopped laughing and started making it, and they were putting it in a clear glass. We found ourselves, as the category innovators, behind the category," Celsi explains. "If we didn't react, the competition would take the category, so we went to a clear, or flint, glass with our white zinfandel, and at the same time we decided to update our label. We felt we needed a dramatic package update to gain a lead over the competition."

The design firm at that time came up with two paper labels that Sutter Home was interested in. "We did some consumer research and we learned that consumers are inundated with so many wine packages. There are a lot of labels on the shelf in the wine business, so we went back to the designers at that time and we said 'We don't think we've gone far enough. We want to go further,'" Celsi explains. What they came up with was a clear pressure-sensitive label for the bottle and the neck label remained paper.

As Celsi says, "We went to town. The brand took off and we sold six or seven million cases, and today we're at about ten million. This is for a company that was moving about 30,000 cases in 1976—a true American success story."

[PRESENT DAY]

However, even though Sutter Home was doing extremely well, the market-conscious professionals there knew it was time to change again. "The cycle of innovation to duplication has been increasingly shortened, where you have to change every two years, not every five years," Celsi says. "Realizing that, we couldn't allow ourselves to be in a situation where the marketplace tells us to change our package. We also found ourselves being dragged down by the competition because they were knocking off our package design, but at a lower price point." This led Sutter Home to commission Michael Osborne Design (MOD), which has designed wine labels for many wineries including some of Trinchero's other brands.

TRINCHERO
SINCE 1890
FAMILY ESTATES

[above]
In 1999, Sutter Home's brand-savvy marketers knew it was time to update the brand again. However, when Michael Osborne Design (MOD) was commissioned to do the redesign, the company also wanted to introduce its new name—Trinchero Family Estates—and include it on the packaging with the Sutter Home brand. MOD creatives explored several concepts for the name plate, starting with this one. MOD designer Michelle Regenbogen says of the design, "They're an Italian family, and we wanted it to look Italian. This design looks like an old fruit crate. We also wanted to make sure we included 'since 1890,' because heritage was really important to the Trincheros."

SIGNATURE
COLLECTION

[above]
"We had been told by the marketing department that they wanted to include a signature wine collection," Regenbogen says of this design.

[above]
The leaf pattern was preferred by the Trinchero decision-makers over the first design. "They wanted it to be simpler and they didn't like the T—it looked like an iron brand," Regenbogen recalls. "So we focused on the leaf design."

[above]
This design was ultimately chosen for the name seal. The designers removed "since 1890" because the wine and the name held their own without this phrase. "We just put the best elements together," Regenbogen admits. "We created the grapes in Adobe Illustrator and we spent a great deal of time making sure they would read properly on the bottles because they're going to be really tiny."

MOD CREATED SEVERAL CONCEPTS THAT DID NOT DEVIATE TOO FAR FROM THE CURRENT PACKAGING. "WE THOUGHT IT SHOULD BE A VERY EVOLUTIONARY MOVE, VERSUS REVOLUTIONARY."

Michael Osborne, creative director for the Sutter Home project, says, "This company is really good about keeping their finger on the pulse of the marketplace—keeping their brand updated on a regular basis according to the market and the industry. They have some very savvy brand managers who keep things moving. You can't stay the same too long in this industry because you'll get lost in the shuffle."

There was also another major consideration for the redesign. The Trinchero family had changed the company name from Sutter Home to Trinchero Family Estates, and Sutter Home Winery was retained as a brand name. "We saw this as an opportunity to introduce that to the public," says Michelle Regenbogen, senior designer on the project. "The reason they are changing their name is because it adds perceived value and consistency to the company. It takes them a step up: Sutter Home is not the umbrella anymore."

Celsi adds, "There's a great degree of product parity out there regardless of the category, and consumers will buy the cheapest brand for a lot of products, since they all kind of perform at the same level. Take store brand tomato sauce, for instance: It's not much different than name brand tomato sauce anymore, as opposed to ten or fifteen years ago where there was a marked difference. We wanted to ensure that people saw our brand mark as a quality mark in a sea of labels, where there are very few brands, but a whole lot of bottles on the shelf."

MOD created several concepts that did not deviate too far from the current packaging. "We thought it should be a very evolutionary move, versus revolutionary. On a scale of one to ten, it didn't really make sense for us to move past a three or a four. There is a tremendous amount of equity and we didn't want to confuse the current consumers," Osborne explains. The Trincheros also wanted to give the whole brand a more upscale image. As a result, they have implemented a new glass shape for the 1.5 liter bottles, and they are moving from a screw top to a cork and capsule finish.

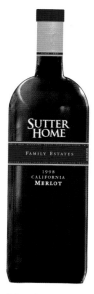

[above]

The next phase in the process was designing the wine labels. Although this first design looks very similar to the old label design, there are subtle differences. For instance, a different font is used, and the colors have been modified. The Trinchero Family members signatures were introduced in the background as well.

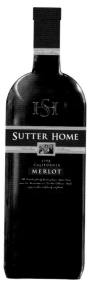

[above]

The designers started introducing the logotype on one line with this design. This approach also included a picture of the Trinchero family. "This was our first step trying to incorporate the Trincheros with Sutter Home," Regenbogen says.

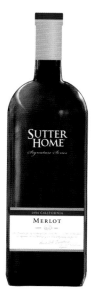

[left]

The signature series was introduced in this design. It captured the heritage with the classic wine label, signed by the proprietors.

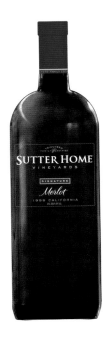

The clients were really drawn to this design. "They liked it because it's very clean and we introduced the Trinchero word mark. The clear label really stood out on the shelf. None of the competitors were doing anything that looked like this." Regenbogen explains. However, they were not finished just yet. "The clients didn't feel there was enough of a color burst on the label—there wasn't anything drawing your eye to it. Color is something they used last time as a differentiator in the varietals." the designers adds.

Osborne says, "We experimented with the Sutter Home word mark, where it appeared as two stacked words. But we thought that particular type treatment looked too old-fashioned, so we suggested putting it on one line with a new type treatment. They've had that word mark for nearly 20 years and they thought that's were the equity was, but we showed them that they can still keep their brand equity—the stacked word mark alone wasn't it." The designers also suggested dropping an old Sutter Home seal, as well as an illustration that had appeared on the label. "You take four or five little things out that add up to a big thing, but at the same time you can't look at the new design and not know it's Sutter Home," Osborne acknowledges.

The new package included the addition of a "Signature" designator for the different varietals, such as Signature Chardonnay. Regenbogen explains, "Part of the problem is that Sutter Home was always considered a value-oriented wine. Part of the solution was to elevate the Sutter Home brand image and perceived value. They want to attract new wine drinkers while retaining the loyal consumers the wine already has."

A serif typeface was used for the Sutter Home Winery name, which gives the wine a more upscale feel, and MOD hired a calligrapher to differentiate the varietals in the brand. "Calligraphy and scripts in general are hard to read unless you do them correctly, so that was a challenging part," Osborne admits. "And since these are varietals, the names chardonnay, cabernet, and so on, have to be easy to read to make a consumer's purchase decision as easy as possible."

The new label would also eliminate the paper neck label—there's now one large, clear label. A foil-stamped emblem was added, carrying the Trinchero Family Estates name. The resulting design is an elegant, upscale representation of the Sutter Home Vineyards brand. "We've increased the perceived quality of the brand with the elegant label design, and by introducing the Trinchero Family Estates name to the packaging," Celsi says.

"THERE'S A GREAT DEGREE OF PRODUCT PARITY OUT THERE REGARDLESS OF THE CATEGORY, AND CONSUMERS WILL BUY THE CHEAPEST BRAND FOR A LOT OF PRODUCTS, SINCE THEY ALL KIND OF PERFORM AT THE SAME LEVEL...WE WANTED TO ENSURE THAT PEOPLE SAW OUR BRAND MARK AS A QUALITY MARK IN A SEA OF LABELS, WHERE THERE ARE VERY FEW BRANDS, BUT A WHOLE LOT OF BOTTLES ON THE SHELF."

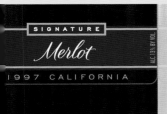

[left and above]

The final design direction for varietals incorporates a hint of color to differentiate the varietals and make the design stand out on the shelf. "The colors we've chosen are different from what they had in the past. It's actually a metallic color as opposed to metallized paper like they had before, so the colors are toned down and more sophisticated," Regenbogen says. Calligraphic lettering was also incorporated for the varietal designators.

MICHAEL OSBORNE DESIGN
GALLERY

[right]

In addition to the Sutter Home varietals, Trinchero Family Estates makes several other brands of wine, including this one designed by MOD. To capture the heritage of the varietals, the bottles are adorned with elegant grapevine illustrations and an asymmetrical word mark. The capsules of the three varietals have unique descriptive copy and colors for easy differentiation on the shelf.

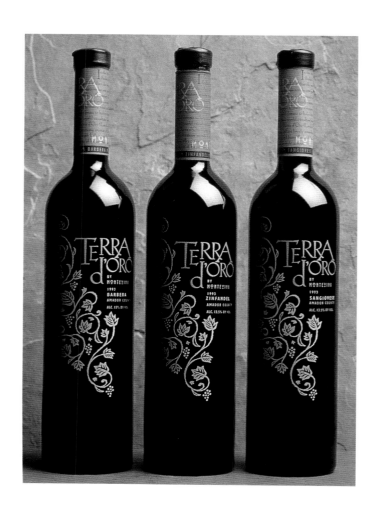

[left]
MOD incorporated pressure-sensitive labels on the Montevina packaging to give the brand more shelf impact. The striped closure and gold sun icon capture a traditional Italian feeling.

[above]
Named after an Italian seaport, this line of premium varietals was designed by MOD. Clear, pressure-sensitive labels serve as a hidden stage to showcase the elegant, metallic gold word mark and rich color palette.

[above]
The Soléo brand, also from Trinchero Family Estates, was redesigned by MOD to introduce three new fruit-flavored wines. The sun on the back label is visible from the front. The colorful design speaks to a vast transitional audience of new wine drinkers.

[3]

MICHAEL CONNELL, MEDIA ARTISTS, INC., ITALY

A brand is a brand is a brand. Whether it is a niche or mass market brand, the dynamics of the brand function equally. It is the environment in which the brand lives that is different, and that changes the rules of how it will impact a specific market. It helps to think of brands as people with personalities, character traits, styles, and an environment in which they live.

I define and visualize the brand and its entire universe, creating a total brand experience and ensuring complete comprehension for all decision makers, and, more importantly, its niche market. My philosophy on **BRANDING TO NICHE MARKETS** is by in large **EQUAL TO THAT OF MASS MARKET BRANDING.** In fact, it is not the branding process that changes but the way in which you do your **RESEARCH.**

The branding process is a general discipline that helps put the elements together that will identify and give inception to a brand. Whether or not it will even be a mass market brand will become apparent during the research and definition phases.

Niche brands are built for specific markets and embody determinate qualities and characteristics, while a mass market brand may be more ambiguous, allowing broader interpretation. Since the target audience is very specific, you need to be specific with your sample—use focus groups instead of broad tele-research.

A few factors that I personally believe are important in niche samples are:

1) Do your own homework. Know the market well. Don't let the marketing experts do all the work for you.

2) Participate in the sample so that you can get an up-close and personal understanding of the sample results. As designers, we have a knack for understanding emotion-based responses and need to be present to interpret the unwritten results.

3) Once you have clear direction for your brand, test it. Get out of your office and talk to people in the niche market. You will be surprised by how much insight you will receive.

4) Finally, I believe that in niche branding it is the details that make the difference. This is why you need to be so involved in the research. Anyone can "generally" understand a market, but if you do not understand the underlying culture of your niche, it will kill any hope for success.

BRANDING
FOR NICHE
MARKETS

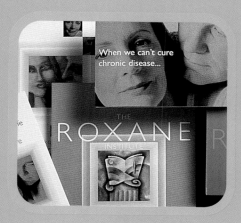
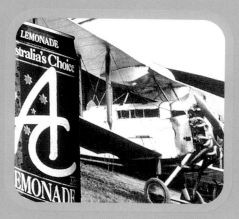
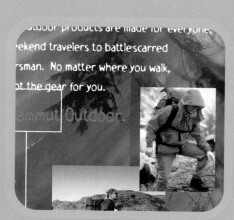

DESIGN
DESPITE REGULATIONS

<div style="border:1px solid">

ROXANE PHARMACEUTICALS
BRAND BY THE DELOR GROUP

</div>

The DeLor Group, based in Louisville, Kentucky, has honed in on a brand specialty that most design firms would shy away from—pharmaceuticals. "It's unlike any other industry. The pharmaceutical environment is very regulated and there are an awful lot of things you can't say," Ken DeLor, principal of the firm says. "It's hard for people in the design business to work in pharmaceuticals because you have to be tremendously patient and you compromise a lot. It takes significantly more time for legalities—and sometimes it's just not logical. It oftentimes isn't a good match for designers and that's why you don't see a lot of really great work being done in the pharmaceutical arena because creatives don't want to invest that kind of time in the details."

Since DeLor's firm has done a lot of work in the pharmaceutical arena, he decided to capitalize on his expertise and contact companies he thought had a design opportunity for building brands with specific levels of expertise, like products associated with cancer or HIV. Roxane Pharmaceuticals, a leader in the palliative care industry, was one of the companies the design firm targeted with its campaign. According to DeLor, "The goal with palliative care is to make people who have chronic and painful illnesses comfortable, as opposed to being in such severe pain they can't take care of themselves. It's not a major blockbuster like antibiotics or a cure for HIV, but it's a way to live with these illnesses and manage the pain."

Although Roxane offers several drugs for palliative care, it did not have a single brand under which to market them. "After seeing some of the other things we've done, they knew what they needed, but they didn't know how to do it. They had to somehow tie these things together so when their sales people walked in front of doctors, the doctors could have a holistic sense of their portfolio," DeLor recalls.

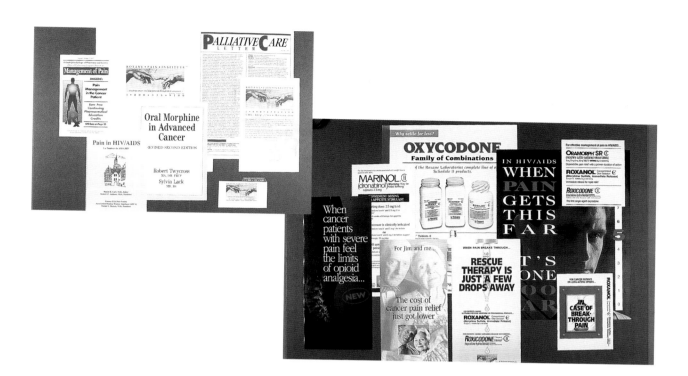

[above, left, and below]

It's clear from these visuals (above) that Roxane did not have a strong identity in the palliative care marketplace. The collateral materials were text-heavy, dark, and uninteresting. The new brand identity (left and below) created by The DeLor Group, has much more visual appeal in print applications, employing colorful illustrations and a clean, open layout.

Illustrations: Joseph Fiedler, Linda Frichtel, Heather Holbrook, and Michael Morenko.

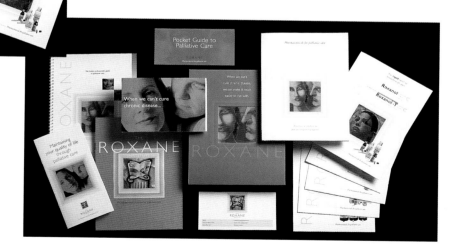

"WE TRY TO HELP OUR CLIENTS UNDERSTAND THAT THEY WANT A SERIES OF PRODUCTS TO SELL UNDER THAT UMBRELLA OF LEADERSHIP, AND THAT'S WHAT A BRAND DOES."

[THE CHALLENGE]

"Roxane had come to the conclusion that they really hadn't put their stake in the sand with palliative care. A lot of the companies that deal with pain drugs don't really have a portfolio. Roxane thought somebody needed to address palliative care," DeLor designer Kevin Wyatt explains. "It's sort of a hot topic—people are worried about assisted suicide because many people in chronic pain just can't live with it anymore. You can maintain life with these drugs. People do not have to die in pain. We were called in to bundle this and figure out the best way to put this together and communicate the message."

There's also a stigma attached to the concept of prescribing drugs to people in severe pain. DeLor says, "As you go up the intensity chain associated with pain, you get into products like Morphine, which are regulated by the federal government for use, even more than the standard Rx drugs. General practitioners and even doctors who treat cancer are hesitant to use highly controlled substances like Morphine because of patients getting addicted to it and all the negative attributes. But the reality is, that happens less than five percent of the time."

Although Roxane does have competition in the palliative care arena, DeLor says it's probably only one of three companies that is really committed to the products that treat not only the pain, but products that deal with the symptoms caused by the pain medications. For example, there are companies that only sell medications that deal with the side effects of the pain drugs which include nausea and vomiting. But, he adds, Roxane is the only one that has established the formality of the brand. "What we're doing for Roxane is making the equation that they are the leader in the category and we establish that leadership position. Other people aren't talking about it in the broader sense of palliative care, they're talking about it in terms of managing pain or managing symptoms. We try to help our clients understand that they want a series of products to sell under that umbrella of leadership, and that's what a brand does," he explains.

The DeLor Group uses the same branding formula with its pharmaceutical clients as it does with its industrial and service-related clients. "First you establish a focus or position in the marketplace, and then you build all the products underneath it to support that position. So when people think of Roxane, we want them to think of palliative care, and then we want them to think of the products that work under that umbrella," DeLor notes. What typically happens with these products is that the doctor will know the name of the drugs, but will not know who makes the

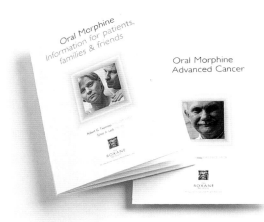

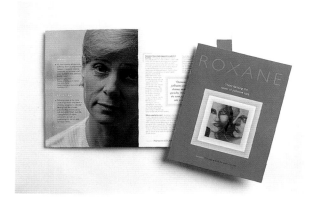

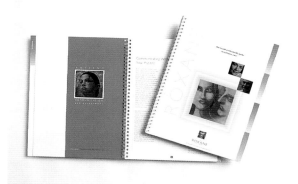

[above and right]

Since palliative care is still a relatively new discipline for some physicians, these booklets were developed to educate them about the treatment, and give them clinical guidelines for prescribing pain medicine. The DeLor Group also designed the folder so all the materials could be presented to physicians in one handy bundle.

[left and below]

To introduce the concept of palliative care to patients, The DeLor Group developed a series of educational brochures and booklets. "This is a good primer for somebody who's going to be on this medication, to help them and their families understand what palliative care is," explains Kevin Wyatt, a designer on the project.

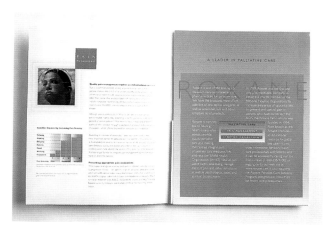

"**WHAT WE BRING TO THE TABLE** THAT'S DIFFERENT THAN HOW MEDICAL AGENCIES APPROACH THIS, **IS THAT MEDICAL AGENCIES COME FROM A CLINICAL BACKGROUND MORE THAN A CONSUMER BACKGROUND,** SO THEY'RE **NOT COMMUNICATORS** IN THE CLASSIC SENSE."

product. DeLor says it is important to establish an equation to identify a product with its partner products and company so it becomes easier to sell the company's next product.

"It seems very simple, except the pharmaceutical business doesn't do that, and they don't do it because of the way they're organized," he explains. "They're relatively new in the idea of marketing products, particularly in the sense that technology allows the products to get out faster. Even if the companies wanted to, they don't have time to build that brand equity because by the time they put out one drug, there's someone right behind them introducing it as the competition."

[DEVELOPING A STRATEGY]

The DeLor Group attacks its branding projects in several phases. Phase one is called "Research and Orientation," where a team of marketing professionals with an emphasis in communications—not design—meets with the client and determines how they are going to solve the branding problem. These people work closely with the client conducting research to understand both the doctors' needs as well as the patients'. "What we bring to the table that's different than how medical agencies approach this, is that medical agencies come from a clinical background more than a consumer background, so they're not communicators in the classic sense," DeLor explains. "Oftentimes pharmaceutical companies really end up focusing on the science to the doctor, as opposed to the benefit to the patient. There are lots of clinical charts that are used—it's very scientific. We say 'Okay, we hear all that, but what does that really mean to the patient?'"

After the research is finalized, DeLor's marketing team recommends a platform that directs and reinforces the key message for every component of the package, including direct-mail, advertising, and other collateral materials. "We write a project plan for what we're going to do so that when we pull back the flap string they're excited even though they haven't seen anything visual at this point," Wyatt explains. "It just is a nice way to put in writing what you think needs to happen. Then the designer is brought in to look at it so that we all understand where it's going."

With the designer involved, the real concepting and strategy process for the materials takes place. "We try to get a pulse for what's in the industry—we take a look at what's out there and take a cue of what not to do," Wyatt notes. "In Roxane's case, we looked at using photography initially, but they had been using a lot of promotions with images of its target audience—which was the

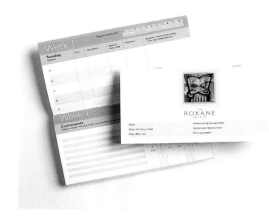

[left]
Since palliative care patients have to retain so much information regarding their medications, doctors appointments, and therapy sessions, this self-care diary was developed for them. The designers used a grid format to help patients and their doctors track their treatment.

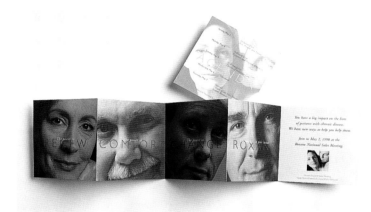

[left and above]
The launch kit and sales training books were designed for the sales force. The fold-out brochure was a teaser to create interest for the upcoming sales meeting.

[left]
DeLor creatives designed this Roxane print ad that appeared in the Journal of Palliative Medicine.

elderly in a lot of cases. But they were stereotypical and it was almost condescending. We wanted to broaden the audience here because palliative care isn't just for the elderly or people at the ends of their lives. There are children, teenagers, and middle-aged people undergoing chemotherapy." To better represent a broader market—and not alienate a particular one—illustration was used because it is less subjective, easier to manipulate, and a much better way to communicate Roxane's messages.

Among the things The DeLor Group learned, is that Roxane had a reputation among professionals as an education resource, but many of those people did not associate Roxane with the products. "A lot of pharmaceuticals don't take advantage of the corporate brand. Each product has its own logo and our research shows that people don't know who makes the individual products. We had to un-brand them and make them all one brand under the Roxane name," explains Wyatt. One of the ways they did this was through color. Roxane's corporate color had been brown, but the creatives convinced them to change their color to blue to soften their image.

[IMPLEMENTING THE SOLUTION]

The design firm created brochures for the sales staff to use as a selling tool. One of the pieces discusses the state of the union on palliative care. "It doesn't promote any products. It just discusses the issues," Wyatt says. "Sales forces used it to go in and sell a drug—they had never gone in as a consultant, so we were trying to train them with these new tools and arm them with the answers and information to address the doctors' concerns and questions about the drugs."

The overall package The DeLor Group created for Roxane has raised awareness of palliative care and of Roxane's leadership and expertise in the category. But DeLor says it's too soon to know if the brand's revenues have been dramatically impacted. "Branding programs require building equity in the product or company over a long period of time. With Roxane, it is a whole new way of selling, so results can't be measured over the short term. Building equity requires patience— for the long-term investment," he explains.

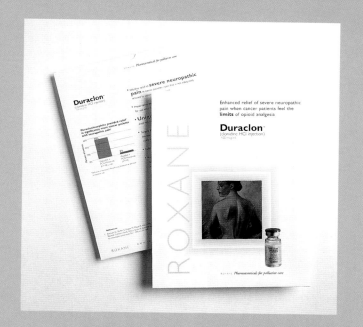

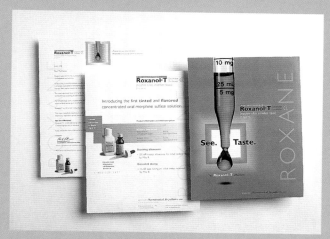

[above]

Each Roxane medication needed an information sheet to explain what the product is and what it treats. The designers developed these product sheets for the salespeople to give to physicians.

[left]

Wyatt designed this direct-mail campaign that encapsulated the entire Roxane program, from an overview of palliative care, to specific information on the products themselves.

THE DELOR GROUP

GALLERY

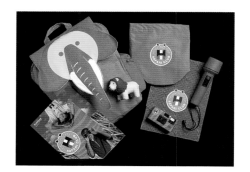

[right and opposite bottom]
Eli Lilly and Company produces a drug called Humatrope, which is prescribed primarily to children who have a growth hormone deficiency. To make the medication more kid-friendly, The DeLor Group redesigned the Humatrope collateral materials. "We came up with the idea of creating a club the kids could belong to," explains Wyatt. "They became 'Humatroopers' and they receive a backpack and other fun stuff."

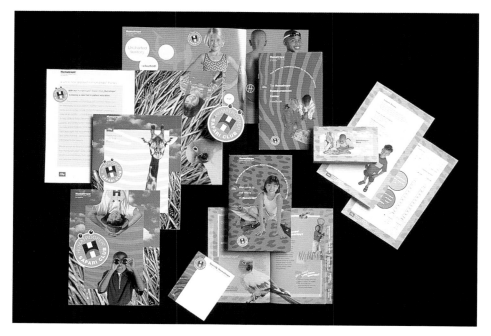

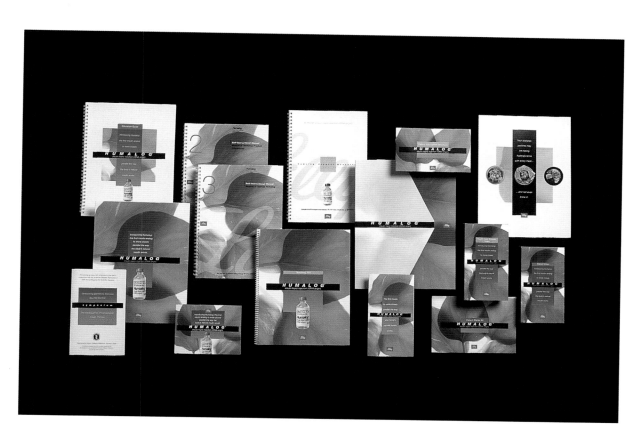

[above]
The DeLor Group created an entire communications campaign for Humalog, an insulin product, introduced by Eli Lilly. After exhaustive research and concepting, the designers came up with this comprehensive brand identity system.

REVAMPING
A BRAND FROM DOWN UNDER

AUSTRALIA'S CHOICE
BRAND BY SUTER AND SUTER DESIGN CONSULTANTS

When many of us think of Australia, we refer to the movie "Crocodile Dundee." However, that could not be further from reality for native Australians who take tremendous pride in their heritage and relish their continent surrounded by the ocean. So, when the owners of the K-Mart stores there were faced with redesigning its independent brand of soft drinks, aptly named Australia's Choice (AC), they took that to heart. According to Donna Blakely, former brand manager at K-Mart, "The whole idea is that it is made by Australians for Australians, and we didn't want the package to look touristy. People here are very proud of their origins, so we thought this was a great opportunity to capture our culture's values and history through the packaging."

In 1998, Cole Myers, the company that owns K-Mart in Australia (it is independent from the U.S. chain of K-Marts), had two reasons for redesigning the soft drink packaging: They wanted to go with a more conveniently shaped cube package and they wanted to capitalize on Australia's culture and history in honor of the fact that the 2000 Summer Olympics were going to be held in Sydney. "At K-Mart we sold AC in what we called a 'slab'—an old fashioned corrugated boarding product. That's the way all soft drinks were sold in Australia until Coca Cola brought in the cube, which is a much more attractive and practical package," Blakely explains. "The slab packaging was unbecoming, you couldn't store it in the refrigerator because of its awkward size, and the printing was very coarse."

She continues, "We also had a time when AC was very flat and it became a very stagnant brand, so we wanted to re-launch the drinks and pump back some of that brand recognition to the consumer, and move into the cube format. There were no advantages to staying where we were. The slab packaging actually made the product look more generic, and the old labels were pushing our brand down."

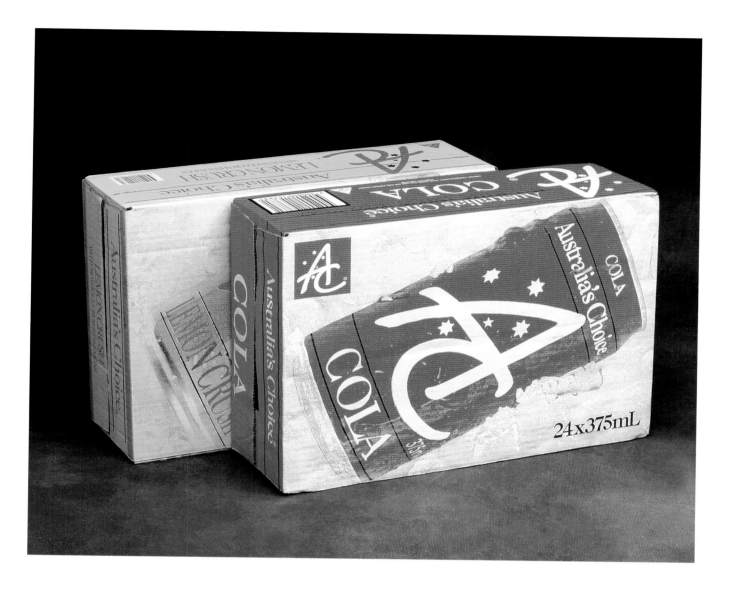

[above]

The old packaging for Australia's choice was bland and outdated. "It didn't communicate who we were— an Australian brand, made by Australians," says Donna Blakely, former brand manager of K-Mart Australia.

"PEOPLE HERE ARE VERY PROUD OF THEIR ORIGINS, SO WE THOUGHT THIS WAS A GREAT OPPORTUNITY TO CAPTURE OUR CULTURE'S VALUES AND HISTORY THROUGH THE PACKAGING."

[DEVELOPING A STRATEGY]

Blakely was determined to increase the brand awareness of AC through the redesign. "It was an opportunity to sell the value of the brand through the packaging. We wanted to capture the consumer's eye and be a little different," she says. "And Australia doesn't have a lot of private labels. We wanted to play up the tagline, *You can't taste the difference. Why pay the difference?* It was really informing the consumer that this tastes just as good as the national brands, but you're going to pay about 40 percent less."

Designer Phil Suter of Suter & Suter Design Consultants was brought in to conduct the redesign. "Cole Myers wanted to show the public that they are an Australian company now and at the same time they wanted the design direction to center around the greatest sporting event of the next millennium," the designer recalls. And what better way to do this than by using Australian images on the packaging?

However, as Blakely states, some guidelines were enforced as far as which images to use. "We didn't want to focus on photos of, say, Harbor Bridge, because from a marketing point of view it isolates some people if their city or town isn't on the case. The starting point of the idea was there, Australia for Australians, but we didn't want to make it look like we were selling to the tourists coming over for the Olympics. That's not the idea of the brand," she explains.

Suter went to various sources to search for the sort of cultural images he thought were truly Australian. The first image he found was a picture of a ute, an Australian colloquialism for a utility vehicle or pick-up truck. "That particular car was the first Australian automobile designed and produced here, so everybody is familiar with that here," Suter says. "It really depicted the starting point of GM in Australia," Blakely adds. "This set the standard for the rest of the series of images we wanted to use. We decided to take away the elements of panoramic tourist pictures and bring it back home and tie it back to the history of Australia. And these are images that will last and be remembered forever in our history."

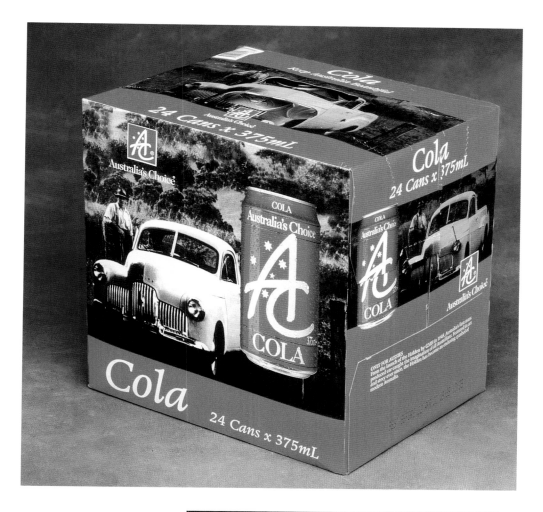

[left]

Phil Suter used black-and-white photos of images that represented Australian history for the packaging. This image is of a ute—the first Australian automobile. "The Holden is a well-known icon here," Suter notes.

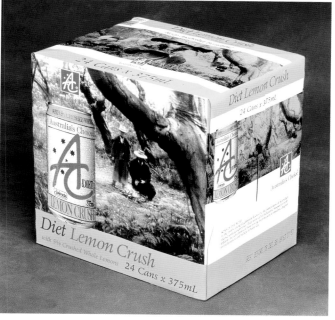

[left]

The photos on the Diet Lemon Crush packaging are of Jillaroos and Jackaroos—the farm people who live off the land. Suter explains, "They're sort of hearty people who can live in the bush. They usually ride horses and control cattle."

[IMPLEMENTING A SOLUTION]

Although some of the pictures were hard to locate, Suter managed to cull enough photos of Australian icons to go on the different AC packages. He then worked with Blakely in the design of the packaging. Since all the photos were black and white, they decided to play with colors that corresponded to the soft drink flavors for each package and they used the can as the brand identifier. "At first we had a monotone wash of the picture of the can and it wasn't strong enough. It didn't stand out," Blakely says. "Phil and I spent a lot of time sitting in front of the computer moving the different elements around and playing with where the colors should be on the package panels."

They decided to feature the can against the black-and-white background, which were the photos. "I increased the size of the can and made it pop out on the packaging by adjusting the angle and dimensions," Suter says. "And when you see that as a mass effect on the shelf where the packages are stacked, the first point of contact your eyes see is the can, since the hero in this product is the AC soft drink—the other elements are secondary."

Although AC is only sold in Australian K-Marts, response to the newly designed product was immediate. "When people walked into the stores and first saw the AC shelves, they said, 'Wow! What's that?'" Blakely says. The only promotional materials the store ran for the product were in-store posters and catalogs, but there was an increase in initial sales.

"This product is an option for the consumer who doesn't want to buy or can't afford to buy Coca Cola or Pepsi, or a person who isn't brand conscious. K-Mart is very much a family store and we know the packaging is successful to the extent that children aren't embarrassed to carry an AC can to school—which is a big deal," Blakely concludes.

[right]

Australia is known as a sailing country and when the Australian team won the America's Cup it was the biggest sporting event down under in recent history.

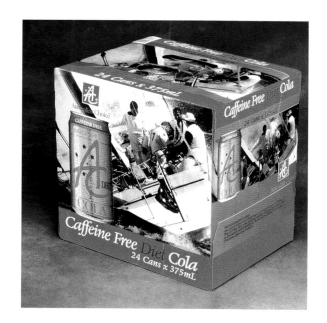

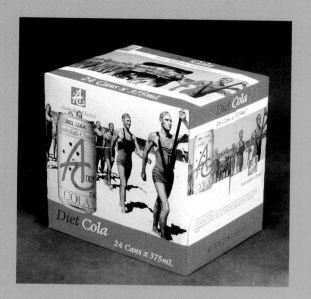

[left]

Since Australia is surrounded by the ocean, there are volunteer life savers who actually patrol the beaches. "They post flags at certain spots, so if you're swimming between those flags and you're in trouble, you'll be saved," Suter says. "Nobody has ever drowned in Australia who has swam between the flags, so this is a very profound image." This photo is dated from the 1930s.

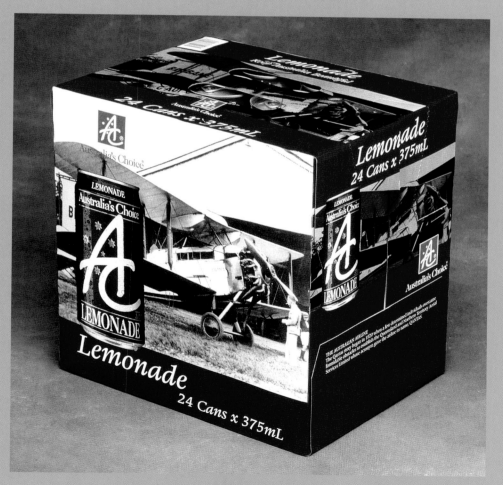

[left]

Quantas was the first airline to ever leave the shores of Australia. It is also the second oldest airline in the world.

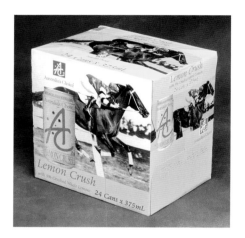

[above]

This particular horse won the Melbourne Cup in the 1930s, and is a proud icon in Australian history. "Because he was so strong, there were certain races where he had to run under a handicap where they loaded him down with lead weights to keep him equal with the rest of the horses. He was very big and strong and popular," notes the designer.

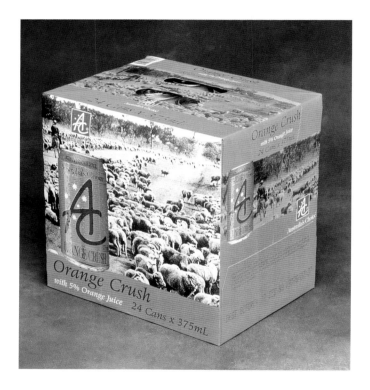

[above]

Raising and herding sheep has always been a way of life for Australian farmers. According to Suter, "In the early days, the farmers decided that certain sheep would survive in this country, so they went out and found a Marino sheep in Spain. The early economy was based on the sheep to get the nation going."

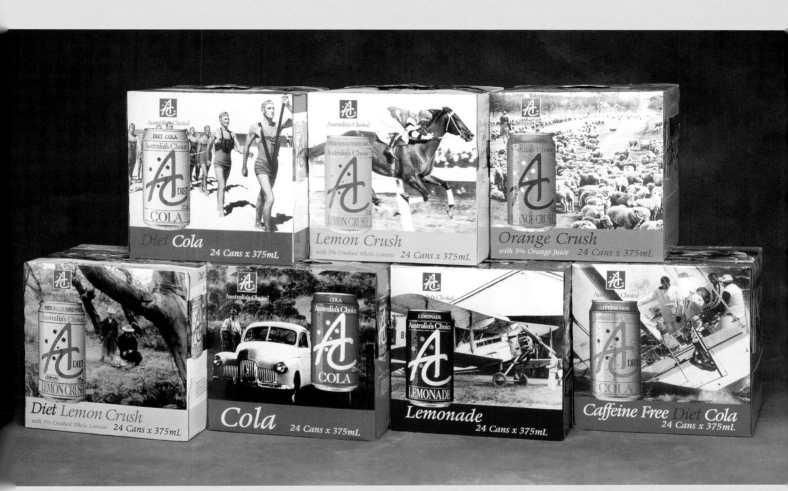

MAKING AN IMPACT
AT THE NEWSSTAND

<div style="border:1px solid #000; border-radius:20px; padding:10px;">

DYNAMIC GRAPHICS MAGAZINE
BRAND REDESIGN BY DGM IN-HOUSE DESIGNERS

</div>

The publishers of *Dynamic Graphics Magazine (DGM)* new they had a great product when they founded the desktop publishing journal five years ago. It filled a niche in the marketplace, providing useful, creative, hands-on demonstrations for beginning desktop publishers who create their own newsletters or promotions. The magazine's designers and editors provide inspirational designs and informative content that *DGM* readers can actually use.

But in their haste to design, print, and distribute the first issue by its target date, the newly-appointed *DGM* staff wasn't able to establish a strong brand identity and package the magazine in a way that would necessarily appeal to advertisers, as well as consumers at the retail level. *DGM* publisher Mike Hammer decided a complete design overhaul was necessary for the magazine to survive.

[THE CHALLENGE]

"With thousands of magazines competing on retail store shelves, having a bold, recognizable presence is essential to success," he says. Initially, *DGM* creative director Tracey Warner and publication designer Jennifer Hammontree-Jones were only going to redesign the cover nameplate, but they soon realized that the magazine needed much more than a better-looking wrapper.

[above and left]

To increase retail sales and attract advertisers, *Dynamic Graphics Magazine (DGM)* was in dire need of a makeover, starting with its cover. The old cover design, shown here, lacked a bold shelf presence and had a tired tagline.

"If we're going to redesign the look, then we're going to package it better," notes Hammontree-Jones. One of the biggest challenges was the name itself. "It's huge. We looked at other magazines on the newsstands, and in most cases, the titles were one word in big, fat, bold, bright type," she adds. In fact, there were discussions early on about changing the magazine name, but for better or worse, they were stuck with it—there's too much equity in it. They also had to retain the word *Magazine* to differentiate the publication from its parent company, Dynamic Graphics Inc.

Together Warner and Hammontree-Jones came up with 50 iterations of the cover logo—stacking the words, experimenting with different typefaces, and emphasizing either *Dynamic* or *Graphics*. All of the designs were posted on a wall and the entire publishing department, including the staff from two other in-house publications, critiqued the logos and narrowed the list down to a few designs. Ironically, the logo everybody liked the most was the first one Hammontree-Jones created.

[IMPLEMENTING THE SOLUTION]

With a direction chosen, the designers then had to incorporate several other elements in the nameplate required by the publisher to boost ad and retail sales, including the Macintosh and Microsoft Windows logos, a brief table of contents, a listing of design software that would be covered in the issue, the *DGM* web site address, as well as the tagline *Quick, cool, creative ideas for Mac and PC.* "When the decision was made to be more software-specific and go after advertisers, we had to have it on the cover and make it clear that *DGM* was behind Mac and PC users. In the past we were unintentionally catering to a Mac audience, but with the redesign we saw an opportunity to attract PC users and advertisers as well," Hammer says.

Although it was a challenge for the designers to make all these elements fit into the top third of the magazine cover (which is the only part visible when placed on the newsstand with other publications), they managed to successfully include everything using a grid system. "It was tough to integrate all that information, but we knew we needed all of it on the cover to pull more readers in, particularly if they are looking for a software program they're using," admits Warner.

The one advantage the designers had over the competition was a clean, consistent, color palette that will change according to the cover photo. "We'll pick up three colors from the cover image plus black, and use that on the cover," Hammontree-Jones says. "Then those colors will be carried throughout the whole magazine."

In addition to pumping up the cover and inside pages with color and graphics, the designers devised a better layout system. Hammontree-Jones and Warner create a variety of themed design demonstrations (demos) for each issue of *DGM* that are meant to inspire readers and help them improve their own designs. Because the demos created for each article look so different from issue to issue, the designers were actually starting from scratch each time they laid out an article, which ate up too much of their time. The redesign helps the designers streamline their workflow which in turn keeps the production of the magazine on schedule.

GRAPHiCS DYNAMiC MAGAZINE

DYNAMiC graphiCs magazine

DYNAMiC Graphics MAGAZINE

DYNAMiC GrAPHiCS MAGAZINE

GRAP**H**iCS Dynamic Magazine

Dynamic
Graphics
magazine
Quick, Cool, Creative Ideas for Mac & PC

DYNAMiC **graphics** MAGAZINE V4N6

Dynamic
Graphics
magazine
Quick, Cool, Creative Ideas for Mac & PC

DYNAMiCgraphiCs
Quick, cool, creative ideas for Mac & PC MAGAZINE

GRAPHiCS DYNAMiC MAGAZINE
www.dgusa.com

GRAPHiCS DYNAMiC
www. gusa.com
MAGAZINE

[left and above]
DGM creative director Tracey Warner and publication designer Jennifer Hammontree-Jones designed several logos for the cover. They stacked words, experimented with different typefaces, and even inserted graphic elements into the word mark. One of the main criteria for the *DGM* redesign was that it had to differentiate itself from its parent company, Dynamic Graphics, so the word *Magazine* had to be included in the name and a more appropriate tagline was necessary as well.

"WITH THOUSANDS OF MAGAZINES COMPETING ON RETAIL STOR SHELVES, HAVING A BOLD, RECOGNIZABLE PRESENC IS ESSENTIAL TO SUCCESS.

"It's much more structured," Warner admits. "We sectioned out the entire magazine to decide where departments should go, and how many pages should be devoted to features, and so on."

"We sat down and tried to figure out how to parcel things so it would make sense to us and be helpful to the reader," Renee Phillips, *DGM's* associate editor explains. "The magazine is now divided into four different sections: Imagine, Create, Explore, and Review. These sections are clearly called out in the table of contents, so if readers are looking for something in particular, say, demos or creative ideas, they can head straight for the Create section. Or, if they're looking for specific software instructions, they know to look in the Explore section." In the table of contents, each section is defined by a certain color, which is picked up and run in a gradient bar at the bottom of each section in the publication. The color bar subtly reinforces the separateness of each section.

Hammer says the results for the staff are immeasurable. "It cuts down on the design time Jennifer and Tracey spend on the magazine because it's formatted in such a way that doesn't require them to start from scratch each issue. It also has a more cohesive look and it's much more compartmentalized," he notes. The first re-designed issue came out in December 1999, and already *DGM* has picked up new advertisers, and retail sales are on the rise.

[right]

Taking some of the logos they had come up with in the first round of comps, Warner and Hammontree-Jones created cover mock-ups to see which logo would work the best and have the most pop on the magazine rack. In addition to the logo, the designers also had to incorporate the new tagline—*Quick, cool, creative ideas for Mac & PC*—a brief listing of topics inside, the web site address, and software programs that would be featured within the issue.

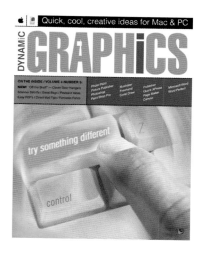
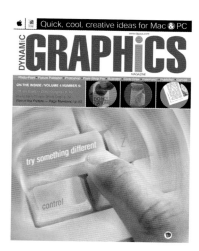
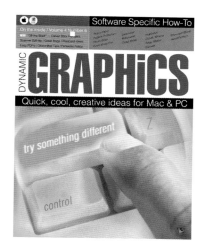

[above]

The designers determined that the top third of the magazine was the ideal spot for the nameplate to appear since that is the only part of the cover that is visible on the newsstand. Hammontree-Jones played with different treatments, including whether or not to use a round or square dot for the letter *i* in *Graphics*.

[right]

This design was ultimately chosen for the cover since it includes all the required elements in an easy-to-read format. The hierarchy of information was crucial as well—the tagline and the Macintosh and Windows logos were purposely placed at the top of the nameplate for instant visibility.

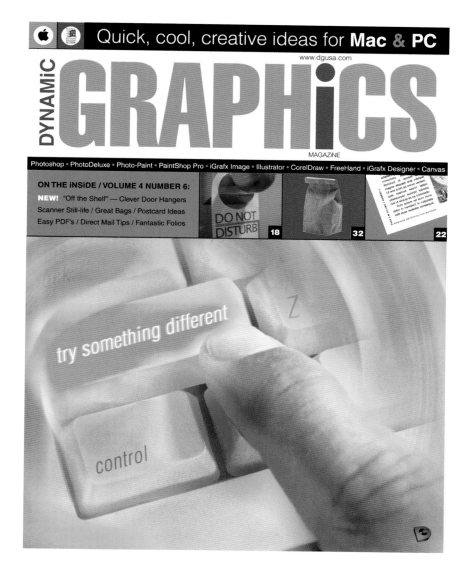

[above]

Once the cover design was established, the designers went to work on the inside pages of the magazine. The information in the old table of contents (top) was difficult to follow and included too many graphic elements and fonts. The new design (below) is much cleaner and it's divided by sections so readers can easily find what they're looking for.

Old layout

[above]

Layouts for *DGM* changed drastically from issue to issue—they lacked a visual continuity which made departments difficult to identify. Publisher Mike Hammer wanted the designers to refrain from using right-hand openers, such as the one shown here, and instead open every article and department with a spread.

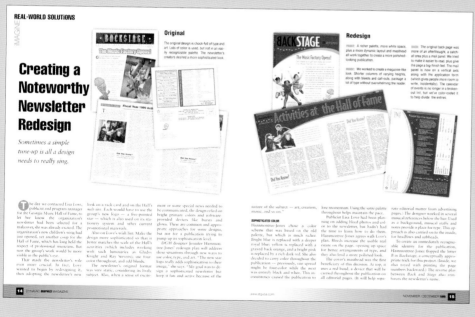

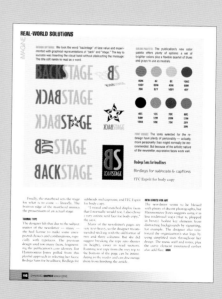

New layout

[above]

To give the magazine a more consistent look, Hammontree-Jones and Warner incorporated a color system that coincides with the table of contents. For example, colors used in the table of contents for a certain department are also employed in a color gradient across the bottom of department pages. To make them stand apart from feature articles, department titles are placed in the top left corner, and the same typeface is now employed in every headline of every department.

USER-FRIENDLY
BRANDING

UNIVERSITY OF PIONEER
BRAND BY MURPHY DESIGN

Pioneer Standard Electronics has taken a fresh approach to employee orientation. Not only does the electronics manufacturer provide training through its on-site school, University of Pioneer, it also encourages employee growth through a progressive program designed to empower and motivate people to further their careers within the company. However, the curriculum materials bing used by the University were not facilitating and living up to the dynamic nature of the program.

"We needed a tool to organize the orientation and help people navigate through it," says Doreen Dietsche, training and development project manager. The previous materials were contained in a plain binder and the information was practically out of date before it could be assembled and distributed. "We wanted something to excite, educate, and empower new employees, and to provide them with standardized information. A lot of employees were frustrated because they couldn't find the tools and resources to help them in their jobs," she explains.

Gayle Patterson, vice president of organizational development, founded University of Pioneer in 1993. Although there was a training department in place before that time, the new program models itself after a real university complete with a library, research center, white papers, and a staff that designs and delivers training. When Mark Murphy, principal of Murphy Design, was brought in, he was initially hired to design an attractive-looking binder and some folders that would contain all the information. But he says, that notion was short-lived. "We discovered that what they really needed was a box that would house several resources. I wanted to combine visual elements and different terminology that was unique to the university, and to give it a consistent look," Murphy says. "Essentially, we wanted to focus the University's mission statement and make it more user-friendly."

[above]

To supplement and support Pioneer Standard Electronics training program, aptly called University of Pioneer, the company needed to implement a standard system and make it more accessible to all employees. Murphy Design's solution was to create a box that would hold all the training materials.

To visually tie the program together, Murphy collaborated with illustrator Steve Dinnino, who rendered all the images for the kit. He created two illustrations for the box and two for the binder, and the designers utilized them on all the different components of the kit. "The whole idea was to develop an illustration of people harvesting fruit," Murphy relates. "The fruit represents knowledge and personal growth, so the people are cultivating opportunity and securing it and working in unison. We also wanted the illustrations to be bright, to create interest and discovery."

Dietchse and Kelly Carson, manager of training and development at Pioneer, were enlisted to organize the massive amount of information that was to be included in the kit. They decided on a hierarchy for the information to determine what people would pull out of the kit first, and then Murphy put all the information in a format that was attractive and easy to use. "Mark made everything just kind of mesh together," Dietsche says.

Materials in the kit include a binder containing all the human resources information and benefits, four orientation booklets, a magazine, and a card game. Murphy says he planned how the illustrations would work with all the materials in the kit. "We cropped specific parts of the illustrations to use on the covers of the booklets and the magazine," he notes.

The kit has been very successful for the University. "Employees are impressed with the kit and have received it very well. It's a great way to welcome someone in to our organization and let them know we want them to be successful," Dietsche says. "The sales and marketing people are excited about the magazine because they can use it as a selling tool to show to their customers."

Murphy acknowledges that the training people were very brave to bring in a designer to collaborate with them. "I give them a lot of credit for changing their current way of thinking and discovering how design can integrate and package their message to motivate people to respond to it," he says.

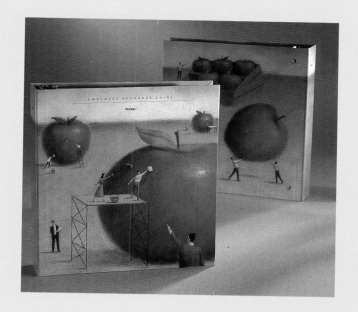

[left and below]
Illustrator Steve Dinnino rendered four illustrations which were dissected and used for all the training materials. The people harvesting fruit represent co-workers at all different levels within Pioneer working together and reaping the benefits.

[left]
A binder and set of informational booklets are included within the kit. The binder materials can be updated as the information changes. To save money, all the booklet covers were printed on one press form, while the interiors were printed two-color on separate forms. Each booklet has its own illustrative identity and color scheme.

"I GIVE [PIONEER STANDARD REPRESENTATIVES]

A LOT OF CREDIT FOR CHANGING THEIR CURRENT

WAY OF THINKING AND DISCOVERING HOW DESIGN

CAN INTEGRATE AND PACKAGE THEIR MESSAGE

TO MOTIVATE PEOPLE TO RESPOND TO IT."

[left]
The Game of Orientation was developed by Mark Murphy to add fun to the program assigning projects to employees and encouraging camaraderie. The cards also double as a puzzle— when all the pieces are put together, it is one of Dinnino's illustrations.

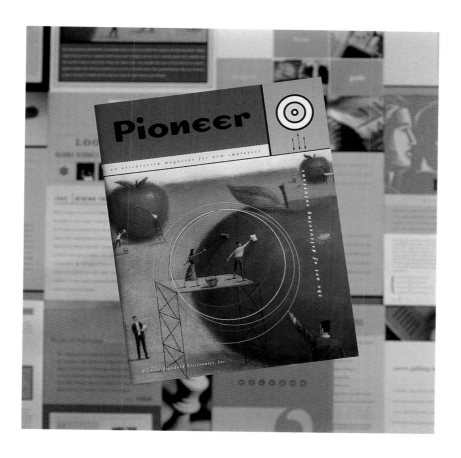

[left]
For *Pioneer Magazine*, Murphy and his team of designers used stock photography and illustrations to balance the flow of information and lighten up the corporate mission statement.

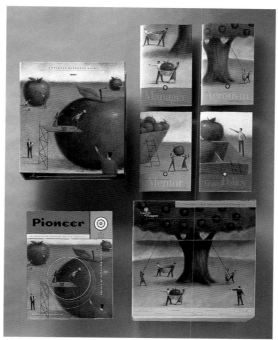

[left]
The entire training program is tied together with the illustrations. Murphy notes, "We wanted to give the university a consistent look, and the bright colors create interest and discovery."

AN
EVOLUTIONARY BRAND

MAMMUT OUTDOOR GEAR
BRAND BY MEDIA ARTISTS INC.

Mammut Mountaineering, based in Switzerland, has been in business for more than a century providing high-end mountaineering equipment and apparel. However, even though the company offered premium quality, high-priced products, the brand was not living up to that standard. "They are one of the top European mountaineering companies, but the brand had never been a priority for the company," says Michael Connell, creative director at Media Artists Inc. (MAI), based in Italy. "They weren't paying attention to the brand."

In 1994, Mammut brought in MAI to evaluate its image and brand identity and develop a brand positioning brochure which would contain business philosophies about the brand and the different product categories. Connell was informed that the company's vision and mission was to "build the world's finest alpine and climbing equipment." However, that vision was not being communicated in the market.

"We looked at the brand, its brand assets, and how they were communicating the brand vision in the market," Connell explains. "Their campaigns and catalogs were overloaded with products, colors, and information, but they were just kind of there. There wasn't any sense of logic or brand. Mammut was presenting a $500 technical jacket and $350 pair of technical pants at the same level that a mass-market brand might present its products. So you build a very expensive and technical product and then at the end of the day you showcase it like a classified ad. It was killing the brand's value."

MAI was not initially given the job to design the consumer catalog, because Mammut was still working with another design firm. "This first project was kind of a test to see if we understood the market, and more importantly what we could bring to their brand," Connell admits. For the brochure, Connell and his associates decided the best approach was to present abstract black-and-white product photography side-by-side with color action imagery and combine it with brand

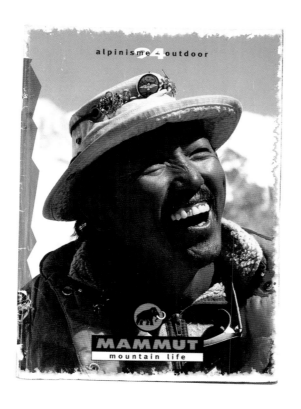

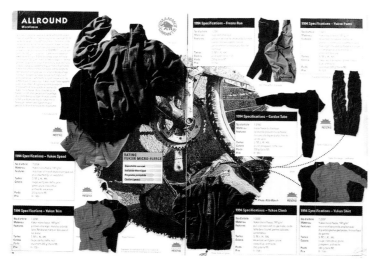

[left and below]

Mammut Outdoor Gear badly needed an updated brand image. The ads and consumer catalogs failed to represent the high quality products the company has been selling for the last century. "The catalogs they were distributing had lots of products with tons of colors, but they were just kind of there—there wasn't a fashion sense." says Michael Connell of Media Artists Inc. (MAI), the design firm that eventually revamped the Mammut brand.

"OUR BRANDING STRATEGY WAS TO MAKE THE TOP PRODUCT FROM EACH CATEGORY A PART OF THE BRAND MESSAGE, MUCH LIKE PORSCHE, FERRARI, AND PRADA MIGHT DO. PRODUCT SEX APPEAL CREATES BRAND IMAGE."

philosophy text, bringing to life their mission and value proposition. "This project took us to the next step with the company," he says. "After we presented this project they began to see clearly how they could visually communicate their brand message in the market."

In 1995, MAI was commissioned to do the consumer catalog and advertising campaign— Mammut's two most important communications channels. The designers first eliminated all the unnecessary materials and information that clouded the brand message, to give more importance to the key products. "Our branding strategy was to make the top product from each category a part of the brand message, much like Porsche, Ferrari, and Prada might do. Product sex appeal creates brand image," Connell says.

Along with Mammut's product managers and product design team, MAI creatives assisted in developing the philosophy for a line of clothing that was to be their signature series. "We don't develop products, but we build the stories around them. We worked on colors and we pioneered the idea to develop the Extreme series because it supports the branding strategy that we were implementing," Connell notes. "The product was the image, and product was vital in positioning the brand. If you looked at the market at the time, everybody was exhibiting beautiful landscape imagery. They all looked the same and few were effectively presenting their products."

In 1996, MAI continued to evolve this brand strategy by introducing imagery that illustrated the challenges and rewards of the sports that Mammut's products are used for. The Absolute Alpine campaign evolved with the addition of black-and-white photos of the most renowned peaks in the world, classifying them as Alpine, while the Mammut product was shown in full color and classified as Absolute Alpine.

"The message was clearly stating the vision of the brand," Connell says. "That year was a continuation of the same concept, but upgrading it by bringing in new elements. When you're building a brand it's key that you maintain continuity and that your brand message remains focused over time."

Following great success with the Absolute Alpine campaign, Mammut decided to differentiate and enhance the communications for the climbing products in 1997. "For the climbing category, we developed a pay-off to support the launch of a new product innovation. To illustrate the new technology, it was decided to use artificial animal fur as the outer fabric, which in turn led us to

126 DESIGNING BRANDS

"THE PRODUCT WAS THE IMAGE, AND PRODUCT WAS VITAL IN POSITIONING THE BRAND. IF YOU LOOKED AT THE MARKET AT THE TIME, EVERYBODY WAS EXHIBITING BEAUTIFUL LANDSCAPE IMAGERY. THEY ALL LOOKED THE SAME AND FEW WERE EFFEC- TIVELY PRESENTING THEIR PRODUCTS."

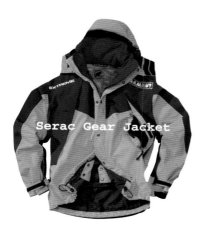

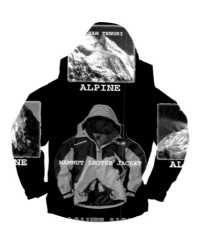

[above and left]
In 1994, MAI was given the task of repositioning Mammut's brand image and creating a brochure to support the company's position. The designers created an upscale catalog through the use of bold photographic images and reversing type against the dark background.

[above]
Connell and his associates at MAI came up with the Absolute Alpine campaign to really push the Mammut brand and show off the products. "We took on the idea to present their products as if they are museum pieces," he says. "We placed the products against the black background which helped position them as high end because the colors of the products themselves are really bold and strong."

[above]
Focusing on the extreme sports enthusiasts, MAI capitalized on the Absolute Alpine campaign, focusing on some of the greatest mountain peaks in the world. "We started bringing in more icons and colors to communicate different values or features for each product," Connell explains.

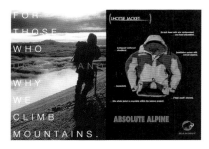

[above]

To create awareness of Mammut's revolutionary climbing harness, MAI devised an ad campaign that only an extreme climber could appreciate. "We developed a new campaign specifically for climbing and, more specifically, for this product," notes Connell. The designers also redesigned the Mammut catalog and streamlined the technical information to make more room for the products.

the concept for the Harness the Beast campaign," explains Connell. "Using the visual of the beast/zebra harnesses coupled with a portrait of Mammut's star climber with his face painted with zebra stripes, we were able to talk about the common fears hurdled by sport climbers and establish an emotional link between core climbers and the brand." Over a three year period, Mammut's advertising had evolved from simple product ads to high impact ads with messages of brand philosophy, product endorsement, and brand image all wrapped in one campaign package.

Since these products are primarily used by extreme sport enthusiasts, Mammut's catalogs were packed with product and technical information relative to mountaineering and climbing, but it clouded and confused the presentation of the products. MAI's team solved this problem by reducing the format and increasing the number of pages, allowing minimal products per page and chromatic harmony between the products and the scenic imagery. They also created a separate black-and-white publication packed with useful information helping the customers safely use Mammut's gear. These simple tactical solutions returned a wealth of brand value through increased product importance and brand image.

By the end of 1997, Mammut had experienced great success in sales and the company had gained a strong position in the high-end market. "They had stepped up to the big leagues and become one of the top brands in Europe, not necessarily from a size point of view, but as a dynamic brand," Connell says. But this was not the end of the story.

Once Mammut secured this position, they realized that the high-end market is a limited market with low margins and it would be difficult to become the global player that Mammut aspired to be. Together with Mammut's marketing team, MAI analyzed the options for growth. The decision was taken to sub-brand Mammut, adding a new category, Mammut-Outdoor, to the existing two, Mammut-Alpine and Mammut-Climbing. Sub-branding Mammut would leverage the existing brand equity and market momentum. Now the challenge was to differentiate the new category from Alpine and Climbing without compromising the high-end positioning of the brand. Mammut couldn't rely on the products alone to sell the image, since they're not dealing with a $500 jacket anymore. "If you look at a Porsche, you don't need a lot of scenery around it. The product is the image. However, if you go to a lower-end product, you need a lot of hip-hop around it to create excitement because the products themselves are not so exciting," Connell explains.

"We started off by developing a new visual communications signature and language, permitting the sub-brand to communicate its new market offering, making it a complete outdoor brand not just for the extremist," the designer says. "From the tree-line up is the alpine region. It's high end. From the tree-line down is where this new group's playground will be." The new tagline that is incorporated for consumer communications is *Mammut Outdoor...For all walks of life*. The designers sub-branded the Mammut logo so that the identity was changed only slightly.

Since the lower-tiered products have been launched, the company grew more than 35 percent in 1998 alone. Mammut is one of the fastest growing brands in Europe, and it is currently expanding into the U.S. market. There is no doubt that the strong brand positioning developed by MAI over recent years revived the century-old company.

[right and below]

In 1997, Mammut decided to roll out a lower-priced product line, so MAI developed a new strategy to promote it. "We came up with different ways to get dealers into the trade shows and get the word out," Connell admits. "Now the product isn't so sexy, so we used friendlier colors, and the imagery was very high saturated, the pictures are blurred, giving a sense of movement." The ads, as well as the catalogs and product brochures, are less technical and more consumer friendly than the extreme product promotions.

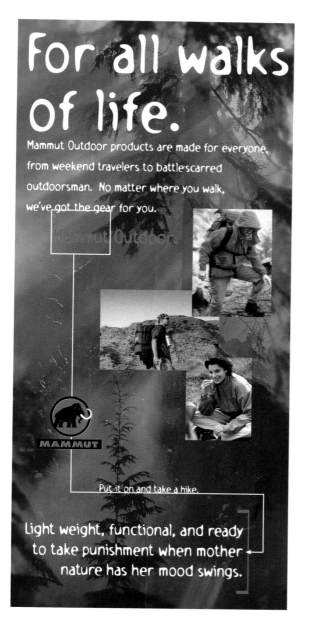

"IF YOU LOOK AT A PORSCHE, YOU DON'T NEED A LOT OF SCENERY AROUND IT. THE PRODUCT IS THE IMAGE. HOWEVER, IF YOU GO TO A LOWER-END PRODUCT, YOU NEED A LOT OF HIP-HOP AROUND IT TO CREATE EXCITEMENT BECAUSE THE PRODUCTS THEMSELVES ARE NOT SO EXCITING."

E A S T
I T H I N

for all wa
of life.

Mammut Outdoor products are made for ever
from weekend travelers to battlescarred

MEDIA ARTISTS INC.
GALLERY

[above and left]

While a noted leader in the winter sports-wear industry, K2 required a completely unique marketing strategy in order to successfully launch its new apparel line, Blood Cells, which is focused on a young target market. "Our brochure design juxtaposed funky shots and underground imagery, communicating the youthful, street image common among teens today." Connell says of MAI's design approach for the brand.

[below]

Fashion brand Cinzia Rocca had a beautiful product but lacked the means of reaching its international consumers. "We breached this gap by devising a point-of-purchase program, including free-standing window displays and an eight-page consumer leaflet depicting highlights from the collection," says Connell.

[above]

Fabric manufacturer, Calamai Corporation, needed a more organized and consistent brand hierarchy. MAI restructured the company's product line by grouping the textiles into four performance categories, and giving each category its own logo, which is used throughout the Calamai campaign. "We elaborated on each fabric group, defining the individual qualities and performance," explains Connell. The newly organized brochure explains the qualities of each fabric in detail.

[4]

STEVEN DUPUIS, PRINCIPAL OF THE DUPUIS GROUP, WOODLAND HILLS, CALIFORNIA

On the average, children see more than 5,000 branded media messages per day. We live in an over-stimulated society where new brands and products are constantly being generated. So when it comes to developing new brands for children, it is never a simple task and it is very unpredictable. You need to find out which brands they respond to and, furthermore, which ones they accept.

Understanding this market can be very challenging—it is in a constant state of change, so when it comes to creating or revitalizing existing brands many issues have to be considered. The most important aspect of the process is to **KNOW WHO THE CUSTOMER IS**. Designers are more successful in creating brands that the target market will accept if they actively take part in market research. This includes actually observing children in the age group and demographic the brand is intended to serve. With this understanding we can better connect our clients' objectives to our customers' desires.

Branding for children is also a double-edged sword, because you have to **WIN THE ACCEPTANCE OF TWO CUSTOMERS: THE PARENT AND THE CHILD**. The parent is looking for brands they trust with products that are quality- and value-driven, while the child is looking for products that are fun and entertaining.

Children's brands also need to be **MARKETED TO SPECIFIC AGE GROUPS**. You cannot be everything to every child. For instance, you can create a brand that appeals to both genders for children up to the age of four or five. But as they get older, there is a pretty clear split, so there are products that appeal to the specific sexes, like Barbie for girls and G.I. Joe for boys.

Once a brand has been accepted by kids, there is no guarantee that it will have longevity. Constant evaluation of the brand performance and **STAYING CONNECTED TO YOUR CUSTOMERS** will give you an edge in this exciting and ever-changing market.

BRANDING
FOR
CHILDREN

CREATING A CHARACTER
THROUGH BRAND DESIGN

BUBBA PRODUCT LINE
BRAND BY THE DUPUIS GROUP

Creatives at The DuPuis Group admit they have a lot of fun developing brand identities for children's products—their brainstorming room is decorated in kids colors, and is filled with an assortment of toys. The group even hosts a kids' day about every six months so the designers can observe children in action. "We invite all of our kids and their friends to come to the office and stay all day," says Steven DuPuis, president and creative director of the DuPuis Group. "We give them toys to play with and watch them interact. It gives us the opportunity as designers to be able to see firsthand what's going on. It's definitely something we focus on here—it's our specialty."

"We had a couple of jobs from Mattel that were running simultaneously, so it was a great opportunity to bring the kids in," Richard Mantor, vice president of client services says. "But it damn near killed us," he adds jokingly. DuPuis also encourages his creatives to visit a nearby shopping mall and toy stores to observe children interacting with each other, and to see what they purchase. With this proactive approach and enthusiasm for the children's market, it is no wonder The DuPuis Group has become a leader in the kids category, designing brands for everything from children's snacks and places children visit, such as Baskin Robbins, to creating packaging for Barbie CD-ROMs and other children's toys.

When Mattel purchased Tyco in 1998, many of Tyco's existing products needed to be updated and some of the lines were extended. The DuPuis Group was put in charge of two main product lines in the Tyco conversion—the girls activity lines, which consisted of Fashion Magic and the Plush line, which included a little known bear called Real Talkin' Bubba. Mantor explains, "Bubba was a popular item and Mattel wanted to extend the line, so they basically 'Matellized' it and gave Bubba a little more identity because the old package was not very impactful and didn't really speak to who this Bubba character was."

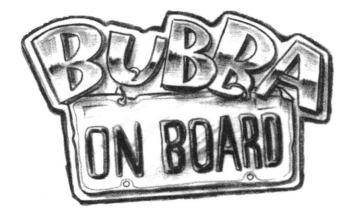

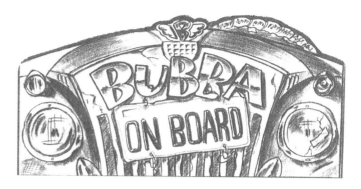

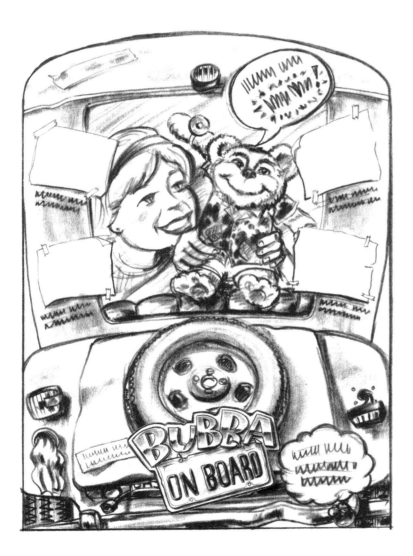

[above and left]
The DuPuis Group illustrator Al Nanakonpanom did these initial sketches for the Bubba on Board packaging. Originally, the designers wanted to include a girl on the packaging playing with Bubba, but they decided that wasn't speaking enough to Bubba's obnoxious personality. "He isn't just a cuddly little teddy bear," says Steven DuPuis. "He's a loud-mouth backseat driver."

"The original brand was kind of flat and it didn't have much dimension," adds DuPuis. "It didn't speak enough to the child and the excitement that this product really has." Mattel extended Real Talkin' Bubba to other characters, including Bubba on Board, Gettin' Wet Bubba, and Nascar Bubba.

According to Toshio Shimoda, former director of Large, Small, Plush, and Activity product lines (LSPA) at Mattel, "Real Talkin' Bubba appealed to both boys and girls. Initially, Tyco thought it would only appeal to girls because it was cute and cuddly, but boys liked him too because he's a jokester."

The creative team admittedly had a lot of fun developing the brand. In fact, Bill Corridori, vice president/creative director at The DuPuis Group says, "We sat around in brainstorming sessions and laughed and joked, and we became Bubba. We helped develop his personality for the packaging based on Mattel's foundation of Real Talkin' Bubba. The concept was to have a sassy passenger with Bubba on Board—a nightmare back-seat driver. He's very obnoxious."

"Bubba's character was an issue," says Shimoda. "The name Bubba has a southern connotation, but we didn't want him to look like a hillbilly. He's sharp and witty, and because of that, he was developed to be put in other situations like the Gettin' Wet and Nascar versions."

Al Nanakonpanom executed the illustrations for all three of the packages, and Nobuko Komine, the senior design director, acted as liaison between Mattel and the creatives, making sure everything was in keeping with Mattel's requirements. Shimoda notes, "The illustrator did a fantastic job—it was very tongue-in-cheek with kids and adults."

The packaging was turned into a jalopy complete with bugs in the radiator, a rag in the gas tank, and bandages on the headlights. "The entire box he's sitting in is part of his personality. There's something interesting on every single panel that speaks to that kind of irreverent persona inside," DuPuis explains. "It also got away from looking like a teddy bear or a cute little toy. The branding spoke to the personality of the toy and it has a much stronger appeal on the shelf."

[left]

Since the packaging for Bubba on Board was going to be a dilapidated jalopy, the designers created a logo that looks like a dented up license plate, just barely clinging to the screws holding it in place

[left]

Nanakonpanom created this splashy logo for Gettin' Wet Bubba in Photoshop. "We really wanted to capture the essence of the toy, since it can be taken in the bathtub or swimming pool," explains DuPuis.

[right]

For Nascar Bubba, the designers created racing elements to go on the race car packaging. Since Mattel also owns Hot Wheels, it was a natural to include that on the packaging with the Nascar logo and a black-and-white checkered flag.

In fact, the package has become part of the toy, because instead of throwing it in the garbage, many consumers kept the jalopy box as a holding place for Bubba. "Real Talkin' Bubba's successors were very successful mainly due to the packaging because it was part of the personality. Consumers that looked at it really liked it because wasn't an ordinary stuffed animal package," Shimoda explains.

The packaging for Gettin' Wet Bubba is filled with colorful illustrations created by Nana. "It's such a busy package and it's fun—it's almost like a Find Waldo," Mantor says. "The whole idea was to translate this same personality into an underwater guy—a toy kids take in the bathtub or pool," Corridori relates.

A natural extension to the line was Nascar Bubba, because as DuPuis relates, "You take this irreverent character and he's going scuba diving, and you know he's going to go to the races. I think Nascar was a given." Mattel got permission to license the Nascar logo, and it fits nicely with the company's Hot Wheels division. Nascar Bubba wears a helmet and its packaging is reminiscent of a race car.

The Bubba lines have been very successful since the release of Bubba on Board in 1998—it became the number seven selling toy. "Any Bubbas after Real Talkin' were very successful mainly due to the packaging," Shimoda says. "[The DuPuis Group] understood Mattel's marketing objectives."

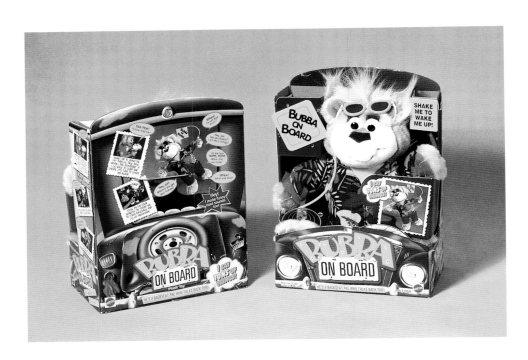

THE PACKAGE HAS BECOME PART OF THE TOY, BECAUSE INSTEAD OF THROWING IT IN THE GARBAGE, MANY CONSUMERS KEPT THE JALOPY BOX AS A HOLDING PLACE FOR BUBBA.

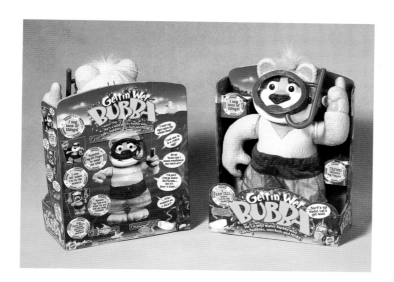

[opposite, right, and below] The packaging for all three Bubbas proved to be very successful selling points. Not only does it house the products, kids consider it part of the toy. Notice how no space is wasted on any of the packages—every panel is brightly colored and loaded with fun images.

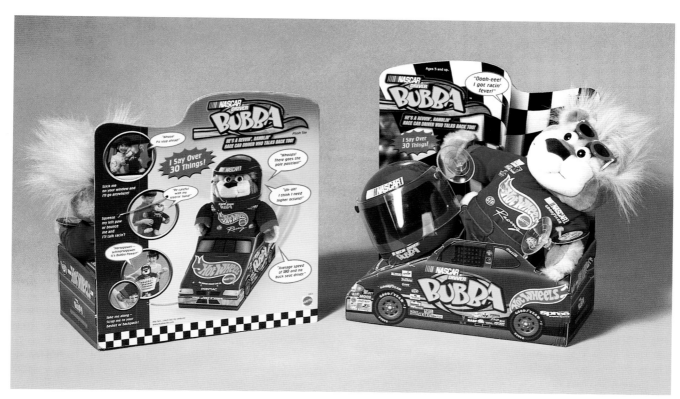

EXPERT ADVICE
FROM THE DUPUIS GROUP

THE DUPUIS GROUP
GALLERY

The DuPuis Group has successfully developed brand strategies for several children's products over recent years—in fact, it's the firm's specialty. "Our understanding of children provides our clients with a knowledge resource," says Steven DuPuis, president and creative director of the firm. "We watch what's going on with kids and what's popular today and that really gives us a pulse of how we need to position products."

"It's gotten a lot easier as of late because of the success of a lot of the children's packaging we've done—clients now listen to us more," relates Richard Mantor, vice president of client services. "Brand managers and marketing managers get a lot of numbers in front of them, but they never get to the *how* and *why*. Why is this product selling? How come this is a phenomenon that appeals to both boys and girls? How has this happened?"

"Many times the client won't like what we've come up with, but we tell them, 'You're not supposed to like it because this is geared for children,'" says DuPuis. "This is probably one of the biggest challenges we face. Brand managers tend to believe that they know what is truly best, and sometimes they are right from the marketing side, but we're coming in from the visual side. We're finding that a lot of them have lost the connection with their customers because of the day-to-day stuff of just getting their jobs done—they don't have the time to go out and experience how their customers make their purchase decisions."

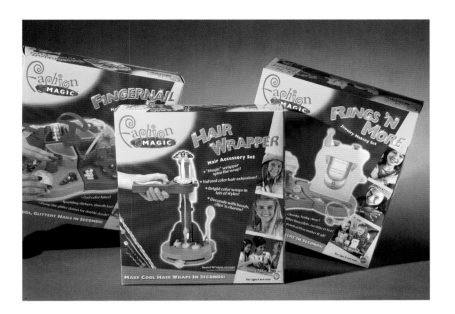

[left]

The DuPuis Group re-positioned Mattel's Fashion Magic line with a full packaging system that expresses a magical, free-spirited style. The designers used bold purple and yellow colors on the packaging to give the product shelf impact.

[left and below]

Baskin Robbins wanted to create an area within its stores that kids could identify as their own, without completely remodeling and redecorating existing stores. The designers came up with the name Frozone and used outrageous colors, graphics, and product names (Dirt & Worms, Skullicious) to section off the kids-only area of the store. Illustrations give ice cream flavor descriptors on the windows above the ice cream for children who are too small to see into the dipping cabinets. Baskin-Robbins also launched a new line of kids beverages, which The DuPuis Group designed, called Radical Blast.

[above]
Mattel asked The DuPuis Group to give the Polly Pocket logo a face lift and give it a more contemporary look to enhance the line's image. The designers beveled out the edges of the typeface and added shading within the letters, then backed it up with a drop shadow to give the logo more prominence on the package.

In fact, The DuPuis Group hosts a kids' day where they invite close to 20 children of various ages to spend the day at the office and play with merchandise that the firm is currently developing branding strategies for. The creatives are able to glean information from observing the children's play patterns as well as learn what kids of certain age groups are drawn to, and the differences between gender preferences.

"Play patterns are very different for boys and girls. Boys want something very active. They always want to be moving. Girls like to talk," Mantor explains. "On girls' notebooks you see soft, cuddly creatures, and if you look at boys' notebooks its aggressive, dueling creatures or wrestling stars—it's all done through an illustrative style."

DuPuis adds, "It also depends on the age group. With the soft look you're going for three to five year olds, and it will look different as they get older. Characters are very important when the child is younger, but as they get older, they don't relate to them as much."

The hardest job, the creatives admit, is when a brand manager doesn't know the age group for the target market. "You look for the core audience," Bill Corridori, vice president and creative director explains. "If they don't have that, we attempt to create it based on their findings."

Colors are very important in communicating the concept for children's packaging, and sometimes it's hard to keep up with the trends. "Colors change dramatically from year to year—same with graphics," DuPuis says. "This market is very much dictated by time—it swings back and forth a lot. That's why so many products fail. This market is extremely fickle and if you're not right on target you're going to lose."

"It's incredibly fast, especially in international markets and with the Internet," Mantor agrees. "If the big companies can't get to the market on time, they've missed it."

"Product life cycles are pretty short. It could be popular now, but in a few years it's passé. It's constantly revolving into something new," DuPuis says. "You start to look at what's happening with our children—the amount of movies and licensed products they're being bombarded with every day. It's disheartening the kind of disposability we have for products. The competition is tough and there's constantly something new that kids want. That's why we are always having to be on that edge and know what's going on out there. You have to take risks. You can't be conservative in this market to have a major hit on your hands."

"With a target audience of mothers of children ages five to ten, we took a 'cyberspace Nintendo-esque' approach to the overall graphic look," says Steven DuPuis, president of The DuPuis Group. The CyberJuice C embedded in the digital galaxy juice swirl defines the brand personality.

The Jewelry Designer CD-ROM was one of five packages in Mattel's New Media line. The DuPuis designers created a shimmering, jewel looking brand that added value and fun to the packaging and set it apart from the other CDs in the collection. A large shot of Barbie introducing the product was placed in the foreground to leverage the strength of the Barbie brand.

"OUR UNDERSTANDING OF CHILDREN PROVIDES OUR CLIENTS WITH A KNOWLEDGE RESOURCE. WE WATCH WHAT'S GOING ON WITH KIDS AND WHAT'S POPULAR TODAY AND THAT REALLY GIVES US A PULSE OF HOW WE NEED TO POSITION PRODUCTS."

A TWO-PRONGED
MARKETING STRATEGY

SODEXHO MARRIOTT SERVICES
BRAND BY HANSON ASSOCIATES INC.

Gil Hanson of Hanson Associates Inc. in Philadelphia was faced with a unique challenge when he was asked to develop a brand for a food service division of Sodexho Marriott Services, a new business that was formed when Marriott Corporation partnered with Sodexho in 1998. Because he was working for the school food services division, the new brand needed to appeal to two very different audiences: the customers, who are the kids, and the clients, which include the school boards and the districts that hire them.

"We needed to create something that would be 'kid preferred, mom approved,'" recalls Hanson. "This is a very volatile target audience, because kids change, and three years from now it's a different audience, so we needed to develop a brand that could be updated in a few years."

According to Jim Fisher, vice president of Marketing and Product Development at Sodexho Marriott, creating a brand for the school services division was an opportunity to contemporize the school cafeteria system and make it more appealing to its customers. "I did not want to roll out something that just had better signage," he says. "It has to have substance."

While Marriott has an outstanding track record in the hospitality industry, this new partnership had to be handled delicately so as not to dilute the Marriott brand. And although Sodexho (based in Paris) has a thriving $10 billion food service business worldwide, it does not have as much consumer recognition in the States, so the Marriott name was retained.

Since Sodexho Marriott serves more than 5,000 schools in the United States, building a brand that would appeal across the board became Hanson's primary goal. "We felt if we understood what the kids want, that would be the backbone of our pitch," Hanson says. An initial session with a group of high school students provided the designers with the information they needed to kick off the project.

[left]

The first challenge for Hanson Associates in designing a new brand for Sodexho Marriott's school dining program is to understand the customers' (students) mindset. Three concept designs representing the various brand positions and personalities—sports, homemade, and MTV— were presented to a core group of high school kids. The preferred design, MTV, clearly addressed customers' preferences.

1

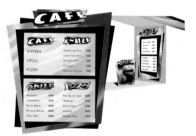

2

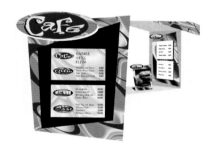

4

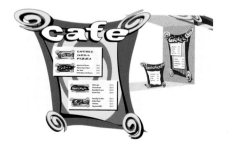

3

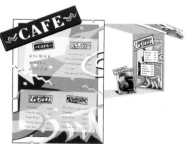

[left]

After careful analysis of their initial research, Hanson Associates developed four design alternatives, each representing a different aspect of contemporary culture. The four design sets were distributed to eight dining units from four regions across the United States for quantitative testing. With more than 6,000 responses, it was clear that Number 2 was the preferred style, as chosen by sixty-seven percent of the respondents.

"We found out that all the kids eat at convenience stores; the social environment is just as important as the food as far as they're concerned; and they like going places that are cool," Hanson notes. When the kids were asked what they thought was cool, they said MTV and sports. "We also learned something very interesting—the best food is made at home by mom, which coincidentally, they don't get that often anymore," the designer adds. In addition, he learned that when kids dine out, they most often go to diners and family restaurants.

Hanson's team of designers developed three different design directions or personalities based on these findings to present to formal focus groups across the country. They included homemade, sports, and MTV. Rather than dividing the test groups by geography like East, Central, and West Coast, the kids were divided by their more immediate surroundings and upbringing—urban, rural, middle class suburbs, and affluent suburbs. "We assume that kids in inner-city Chicago are similar to kids in inner-city Boston or Los Angeles, same with the other groups," Hanson says. "There's a common ground across the country."

The designs were then presented to two age groups—fifth and tenth graders. Overwhelmingly, the MTV look was chosen. As Hanson relates, "In focus groups you don't get a look, you get a mood." The designers then created four designs based on the MTV look to test quantitatively. "We did what we call a beauty contest with kids from eight schools across the country—about 6,000 kids," Hanson says. All the designs were colorful variations of a contemporary, stylish look. Sixty-seven percent of the kids zeroed in on one design.

The next phase of the project was coming up with a name. Sodexho Marriott's business dining service is known to its customers as Crossroads Cuisines, so the company wanted to maintain that name for its school services division. "The school division is very similar to the business dining service. The colors and graphics are different, but the concept of a food court is the same, as well as some of the products," explains Fisher. "Marriott is the business side of the business—our clients know that but the customers don't. You would never say the Sodexho Marriott Café, because that doesn't mean anything to people."

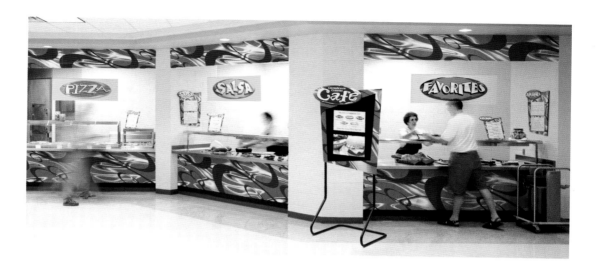

[above]

The trade dress architecture included welcome identification signs, overhead station identifiers, menu boards, and counter top displays. A continuous architectural accent was developed to increase brand personality with maximum flexibility and price efficiencies.

[above]

Once the design direction was chosen, a name needed to be designated for the school dining service. Playing off the business dining name— Crossroads Cuisines—Hanson and his design team came up with the name Crossroads Cuisines Café, and tweaked the type and graphics for the brand's retro imagery.

"WE NEEDED TO CREATE SOMETHING THAT WOULD BE 'KID PREFERRED, MOM APPROVED.' THIS IS A VERY VOLATILE TARGET AUDIENCE, BECAUSE KIDS CHANGE, AND THREE YEARS FROM NOW IT'S A DIFFERENT AUDIENCE, SO WE NEEDED TO DEVELOP A BRAND THAT COULD BE UPDATED IN A FEW YEARS."

"WE FOCUS ON CLIENTS' OBJECTIVES AND WE WORK HARD TO UNDERSTAND BUSINESS AND MARKET OBJECTIVES AND THE TARGET AUDIENCE THEY WANT TO SELL TO."

"In the food industry it's very hard to trademark or own a name," Hanson notes. "So we trademarked the design, or image." Playing off the name Crossroads Cuisines, the designers designated the school services division Crossroads Café, so it would be more effective on the client side to sell the program, yet appeal to the kids with the style of a trendy café.

Food stations were identified simply by food categories such as Pizza, Salsa, and Grill. "Usually what happens in food service and restaurants is that instead of having a product, you have a menu and the menu is driving the brand. In other words, a great restaurant is only as good as the food it serves," the designer explains. "And this is for kids—they see it everyday and the brand becomes meaningless whereas the food item doesn't."

In addition to the brand having a cool style, it needed to be functional and cost-effective. The designers created menu boards, welcome signs, countertop displays, as well as lively, colorful wall coverings to brighten up what is otherwise a plain-looking cafeteria. The signs are computer-generated prints that are laminated to Lexan for durability. They are then magnetically mounted to the walls, so in a few years when the imagery looks dated, new graphics will be generated and remounted.

The reaction to the brand has been very positive—both from the client point of view, as well as the customers. "It's contemporary, it's energetic and the clients like it because it increases the student participation. The kids can relate to this better," says Fisher, who also notes that the people who operate the school café play an integral role in its success. "If they aren't happy or excited about this, it's going to show in the product. The main thing I like is that we're treating the customers as though they have competitive options."

[above and left]
Since a generic approach was
determined for the food station
identifiers, the designers combined
vivid colors and visuals, combined
with oval and trapezoid shapes
to create the signage. The simple
name identifiers allowed for clear
readability, while creating interest
and fun.

HANSON ASSOCIATES INC.

GALLERY

[right]

Hanson Associates was asked to update Finlandia Vodka's brand image for its North American customers. "Market research indicated that U.S. consumers who prefer imported premium vodkas were not buying Finlandia. It was perceived as foreign, cold, and distant," Gil Hanson recalls. To give the brand a more refined image and better shelf presence, the dark label was removed from the old packaging (far right) and the bottle was redesigned with a smooth, melted-ice texture. Since the new brand identity was introduced in April 1998, Finlandia's U.S. sales have increased 25 percent.

New

Old

[left]

Tasting kits were developed for Finlandia's sales reps to use as a selling tool. "It's a lot like a wine-tasting kit—it gets the distributors and bartenders to taste the product and compare it to the competition," Hanson says. All the components of the kit feature the melted-ice texture seen on the bottles.

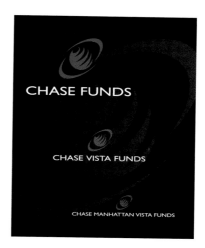

[above]

Chase Manhattan Bank needed to create a separate brand identity for its mutual funds division, but it still needed to visually tie in with the bank's other ventures. Hanson Associates came up with a globe icon representing the bank's diversified, global market.

[above]

There were many challenges Hanson faced with the redesign of the Cool Whip brand. It was already a leader in dessert toppings, owning more than 70 percent of the category, but it needed a more contemporary appearance, as well as a distinctive look for each of its product varieties—Regular, Lite, Free, and Extra Creamy. Hanson replaced the previously-used photographs with illustrations of fruit being dipped into the Cool Whip and recipes were moved from the backs of lids to the outside of the tubs for easier reading.

BRANDING
WEIRDNESS

YTV BRAND

BY BIG BLUE DOT AND YTV STAFF

When YTV was introduced in Canada in 1988, it was the only children's broadcasting network in the country at that time. Though it was extremely successful, it didn't have an established brand. "In the early 1990s, we recognized the need to create a strong brand identity and distinguish ourselves from other networks," explains Dolores Keating-Mallen, creative director at YTV.

In 1992, after hearing Scott Nash, founder of Big Blue Dot, speak about the importance of branding to kids at the Promax/BDA conference, YTV representatives approached him to ask for his help in developing their brand. "They asked us to conduct an audit of the YTV brand and talk to them about how to develop the brand further because they felt they were growing, and they perceived there was going to be competition," Nash recalls.

The first meeting with Nash was a delightful eye-opener for the YTV staff. "Scott spoke in-depth about children and their personalities and what you need to do for kids, versus adult audiences. We were thrilled that there was somebody who cared about the children's market like we did, and who recognized that kids are not passive viewers—they want to be entertained just like everybody else," Keating-Mallen says.

"We're sort of like creative visionaries in that we come in, do our work, and if we do our work well, the network goes off and turns it into something great," explains Jan Craige Singer, president of Big Blue Dot. The creative team developed a brand strategy, and working closely with YTV's creative team, they came up with some icons and brand elements to help define the YTV personality. We created an environment—a place the kids would want to go," Singer says. "YTV was sort of like a hang out where kids would want to spend time." The on-air animations featured a toaster that pops up green toast, a sofa chair, and a dinosaur—all carrying the YTV name.

[above and right]

In 1992, Big Blue Dot developed a strong visual brand for YTV by focusing on icons to portray YTV as a place for kids to hang out. "The identity was built around objects that existed within a specific place that was YTV," explains Scott Nash of Big Blue Dot. "But they were fun objects, like a sofa, or toaster that pops up green toast, or a skull, or a dinosaur."

"WE WERE THRILLED THAT THERE WAS SOMEBODY WHO CARED ABOUT THE CHILDREN'S MARKET LIKE WE DID, AND WHO RECOGNIZED THAT KIDS ARE NOT PASSIVE VIEWERS— THEY WANT TO BE ENTERTAINED JUST LIKE EVERYBODY ELSE."

[left]

In 1997, YTV once again needed to reinvent itself as competing networks began eating into YTV's ratings. Thus, the Weird network was born. Even though weird can be interpreted many different ways, Big Blue Dot developed a style guide for YTV's designers which included a color palette, type style guidelines, and guidelines on how to create a weird attitude. *The Book of Weird* even has a "touch" sound system, so when a certain icon is touched on the attached plastic panel, a corresponding sound blasts out.

"Over the years I would see them infrequently and get updates as to what was happening. They grew and got better programming, and they also developed this terrific attitude for the on-air promos—there's a quirkiness to the promos that is very distinctive," Nash says.

[STARTING OVER]

Though the brand was extremely successful, over the years the competition was growing, and imitators followed. In 1997, Nash was called in to help the network update their brand image once again. "Things really changed in the environment because of the increased competition," he notes. "The other networks were copying the YTV style as well. So much so, that it was hard to even distinguish it from the competition, and to complicate things further, there were parallel programming issues making YTV perceived as the old brand."

"When you add the cumulative effect of all those things together, it started to capture some of our audience. We said 'We're not going to sit here and wait for our audience to erode. We're going to be proactive,'" Keating-Mallen recalls. "It was time to reinvent ourselves."

Big Blue Dot creatives did a reassessment of the YTV brand and looked at the emerging competition that was attracting some of YTV's audience. "We looked at one network in particular to see why kids were tuning to it," Nash says. "And there was a clear reason to be there. It wasn't about being a kids' network. It was a place that offered what kids wanted, which was cartoons. Since there are so many networks clamoring for kids' attention, we took our cue from that and decided to offer up something that wasn't packaged for kids, but offer something that kids wanted."

Through focus group testing, the creatives learned to listen beyond what the kids were saying, to what they meant. For example, if a child says something is good, it's not necessarily good. "Good is non-committal to most kids. It's not an expression of great excitement," Nash advises. "But if a kid says something is funny, that's very straightforward and makes a commitment. If a child says something is weird, it's at least interesting to them."

Big Blue Dot's creatives delved into the research and came up with a branding strategy. "We went back to YTV and we told them to stop calling themselves the kid network, and start offering something kids want. You wouldn't call candy 'kids food.' You'd call it what it is," Nash explains. "We said that one of their great assets that they should promote is 'weird.' We suggested that they should become the Weird network, and that they deliver on that promise."

"When this was presented to us, we sat back for about five minutes and then everyone really bought into it," Keating-Mallen says. "At first we had a few reservations about weird, but when we started thinking about it, weird actually meant that we are funny, and quirky, and unpredictable. It really reflected our programming and who we were. There was an eclectic feel to this weirdness, which we loved."

Nash adds, "We presented it sheepishly because it seemed like a risky notion, but they embraced it. It was one of those meetings you hope for, where everybody is applauding afterwards. Everyone at YTV and Big Blue Dot, seemed to understand that we could have a lot of fun with this."

The YTV designers created the on-air animations that have established YTV as the leader in the children's television programming category. Here are just a few examples of the many "personalities" the station has adopted. Dolores Keating-Mallen, of YTV, says, "One of my biggest desires was to take the icons out of the known into the fantasy. I really wanted to give kids a fantasy trip and appeal to their sense of imagination."

[above]

The Rubber Chicken was designed to show a more vulnerable side of YTV. It helplessly bounces around the TV screen and finally lands on its back, pretending that all is fine.

[above]

The Photonic Crustacean is one of the newer, more kid-friendly icons. Its cool transparent shell lets you see its glowing insides.

[above]

The Manic Machine is the technological hybrid of a Formula One racing car and the next door neighbor's annoying dog, Barky.

[above]

Marvin, the explorer, is an unusual mushroom that can jump, fly, hover and stick to walls due to his spring, jet turbine gills, and suction cup bottom. Marvin's always excited about things and that can make him rather clumsy.

[above]

The Octopus is the crazy creature that hides under everyone's bed. He is friendly, bright, and always wants to come out and play.

[above]

Space Lily was designed with girl power in mind. Reports have it that she's the robotic space dudette that NASA astronauts saw floating outside their rocket ship in 1969.

[left]

Speed Cannibal is the Manic Machine's brainy cousin. An oversized brain was surgically implanted into this dragster motorcycle body to make it think faster than a computer.

"SINCE THERE ARE SO MANY NETWORKS CLAMORING FOR KIDS' ATTENTION, WE TOOK OUR CUE FROM THAT AND DECIDED TO OFFER UP SOMETHING THAT WASN'T PACKAGED FOR KIDS, BUT OFFER SOMETHING THAT KIDS WANTED."

With their concept accepted, Big Blue Dot went back to the trenches and developed a Weird style guide for the network to follow which includes a color palette, and tips on how to keep the weirdness in perspective without going overboard. The YTV creative team then ran with the concept, dissecting it and inventing what weird would look like. Keating-Mallen admits, "We've taken this weirdness very seriously. It's a great focus for us, and there's a lot of latitude, because you can continuously reinvent weird." The new tagline for the station became *Keep it weird.*

When YTV launched Weird in September 1998, it focused on a new target audience as well. The old tagline was *You Rule*, and it was targeted to children ages nine to fourteen, but in reality six to eleven year olds were the base audience. "With Weird, we decided to go back to who we actually reach, and what we've discovered since the launch is that not only has our six- to eleven-year-old audience increased, but our nine to fourteen numbers also increased, even though we weren't going after them," says Keating-Mallen.

Shortly after launching Weird, YTV's ratings started to increase dramatically and the network has increased its audience by 30 percent, which is 75 percent larger than the nearest competition. The YTV designers created a distinctive look through their unique illustration style and animated characters. "We've got great art directors, producers, and designers, and they've created a wonderful, weird look for YTV," Keating-Mallen says.

Sally Tindal, of YTV media relations, adds, "The young kids say they don't even need to see the YTV logo, they just need to see the illustrations and backgrounds to know it's YTV."

"They do great work," Nash says of YTV's creative team. "They're a very dedicated group of people. The tone doesn't sound like it's all Big Blue Dot because it's really YTV's commitment to paying out on the brand and understanding that they need to choose a course and run with it. They have the right people in place to truly build a brand quickly and effectively," he notes.

[above and left]

Promo spots are set against funky, colorful backgrounds created by the YTV design team. The unique spiral design is a recognizable element all on its own, as shown with the insect icon. "Kids know they're watching YTV when they see the backgrounds. That's how bold and distinctive it is," notes Sally Tindal of YTV media relations.

[above]

Big Blue Dot has created several brand identities under the Nickelodeon brand architecture for its many programming ventures. The Games and Sports channel (GaS) brand was developed by Big Blue Dot in 1999. Designer Mike Faxon says, "The diamond shape could be a lot of different things, like the shape of a game board or the shape of a baseball diamond, and it can be filled in with different textures and backgrounds depending on the program subject matter."

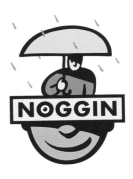

[above and left]

Noggin is a channel and web site co-operated by Nickelodeon and Children's Television Workshop to present their library of pro- gramming, such as reruns of Sesame Street. Ted Smykal, a designer on the project says, "A lot of the design was driven around the logo in terms of split-screen elements. The logo is always illustrated on the lower half of the kid's face and the top part can be almost anything, but it needs to complete the head."

BIG BLUE DOT

GALLERY

[above and left]

Not only did the creatives develop on-air identities, they transformed the YTV look to print for its magazine *Whoa!* It is packed with games, YTV trivia, and upcoming programming information.

[Directory]

BC Design
157 Yesler Way, No. 316
Seattle, WA 98104
206-652-2494

BIG BLUE DOT
63 Pleasant Street
Watertown, MA 02472
617-923-2583
www.bigblue.com

The Bonsey Design Partnership
179 River Valley Road
River Valley Building
Level 5 Unit 1
Singapore 179033
011 65 339 0428
www.bonseydesign.com

Cole & Weber
308 Occidental Avenue South
Seattle, WA 98104
206-447-9595

The DeLor Group
613 W. Main Street
Louisville, KY 40202
502-584-5500
www.delor.com

The DuPuis Group
21700 Oxnard Street, Suite 2040
Woodland Hills, CA 91367
818-716-2722
www.dupuisgroup.com

Dynamic Graphics Magazine
6000 N. Forest Park Drive
Peoria, IL 61614
309-688-2300
www.dgusa.com

Fitch
10350 Olentangy River Road
Worthington, OH 43085
614-841-2123

Hanson Associates
133 Grape Street
Philadelphia, PA 19127
215-487-7051

Leapfrog Design
200 Adelaide St. W., Ste. 400
Toronto, ON
Canada M5H 1W7
416-340-7040
www.leapfrogdesign.com

Media Artists Inc.
Via Marconi 10/A
24021 Albino (BG)
Italy
011 39 35 774115

Murphy Design
1814 E. 40th Street
Cleveland, OH 44103
216-361-1238
www.murphydesign.com

Murrie Lienhart Rysner & Associates
325 W. Huron St., Suite 812
Chicago, IL 60610
312-943-5995
www.mlrdesign.com

O & J Design Inc.
10 W. 19th Street
New York, NY 10011
212-242-1080
www.designcarrot.com

Michael Osborne Design
444 De Haro, Suite 207
San Francisco, CA 94107
415-255-0125
www.modsf.com

SME Power Branding
28 W. 25th Street, 5th Floor
New York, NY 10010
212-924-5700
www.smepowerbranding.com

Sterling Group
Empire State Building
17th Floor
New York, NY 10118
212-329-4652
www.gosterling.com

Suter & Suter Design Consultants
279a Moray St.
South Melbourne Victoria
Australia 3205
011 61 3 9682 8666

YTV Canada, Inc.
64 Jefferson Avenue, Unit 18
Toronto M6K 3H3
Canada
416-534-1191
www.ytv.com